Photographic
Digital Printing

THE EXPANDED GUIDE

David Taylor

AMMONITE
PRESS

First published 2013 by
Ammonite Press
an imprint of AE Publications Ltd
166 High Street, Lewes, East Sussex, BN7 1XU, United Kingdom

Text © AE Publications Ltd, 2013
Photography © David Taylor, 2013
Copyright © in the work AE Publications Ltd, 2013

ISBN 978-1-90770-874-9

Series Editor: Richard Wiles
Design: Fineline Studios

Typeset in Frutiger
Color reproduction by GMC Reprographics
Printed in China

(Page 2)
Sahara Desert, Morocco

CONTENTS

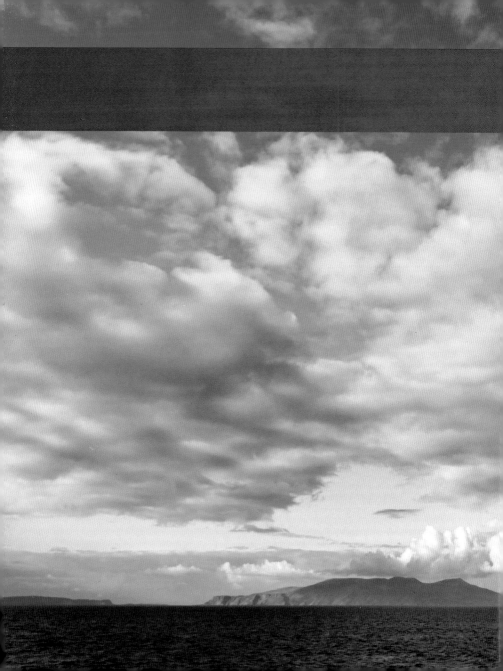

CHAPTER 1　PRINTERS

Printers

To convert the pixels on the screen of your PC's monitor to a physical form you need a printer. Printers come in all sorts of shapes and sizes. Some types are better at certain tasks than others.

The rise of the printer

It used to be so simple. Once, there was very little choice if you wanted a printer. Generally, the same manufacturer made the only printer available for a particular computer model. Now, however, we are spoilt for choice. Printers are ubiquitous. This has partially been driven by improvements in technology. However, the biggest influence on the rise of the printer

has been digital photography. Interest in photography is booming like never before. It's only natural that photographers want to be able to make a permanent, physical copy of their favorite images. Printers allow a photographer to control every aspect of image making, from initial exposure through to the final print. Not so very long ago this level of control was only available to those who were willing to spend hours in a darkroom.

This book is an introductory guide to printers and printing. It is biased more toward image-making with inkjet printers, but there is more general information about the concept of printing to be found too. As much as I like seeing images onscreen, there is nothing more satisfying than looking at a well-crafted print. Creating a print is an art in itself, but it is an art that can be learnt and, for the satisfaction it brings, is well worth learning.

FREEDOM *(Opposite)*
If you can photograph or design an image, you can print it out using a modern digital printer.

PRINTERS
Modern printers aren't quite so cumbersome or difficult to master as their ancestors.

Printer types

Dot matrix

This is the simplest and most basic of the printer types currently on sale today. Dot matrix printers are only really suitable for printing text—though simple graphics can also be printed. The print is formed by a print head comprised of a vertical array of rods. These rods can be raised or lowered to create different patterns. The print head scans back and forth across the printer paper. As it does so the rods strike an ink-soaked ribbon to transfer ink to the paper. It's the rapid repositioning of the rods that forms the shape of the text or graphics.

Dot matrix printers, though simple, are generally very rugged devices. They are also usually cheap to run. Although the print quality isn't usually high, they are ideal for situations where a large amount of text or simple graphical data needs to be printed regularly.

Laser

Laser printers use light in the form of a laser to create a printed output. The laser beam projects an image of the page being printed onto a photosensitive rotating drum. The drum is initially given a positive electrostatic charge. As the laser projects the page onto the drum, the areas where there is type or an image switch to being negatively charged. Once the drum is ready it is coated in toner, which is also positively charged. The toner clings to those areas of the drum that have a negative charge, but is repelled by those areas with a positive charge.

Paper is then drawn into the laser printer and given a negative charge in the process.

> ### *Jargon Busting: toner*
> *Toner is fine, black powder made from a combination of carbon and a plastic polymer. In modern laser printers the toner is held in a replaceable cartridge.*

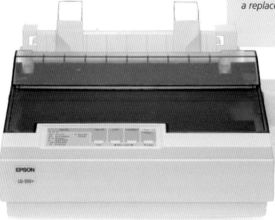

EPSON LQ-300+II
A4 dot matrix printer.

Image © Seiko Epson

The paper is fed around the drum, and toner is transferred from the drum to the paper. As the paper passes over the drum it is given a positive charge to stop it sticking. Once past the drum, the paper passes through a pair of heated rollers that fuse the toner permanently to the paper (and make the paper warm to the touch as it comes out of the printer). Although the process sounds complicated—which it is!—laser printers are capable of printing documents extremely quickly. They are also generally inexpensive to run, and a typical toner cartridge is often capable of printing thousands of pages before it needs replacing.

Initially, laser printers only used black toner. Now, color laser printers are available at relatively affordable prices. Color laser printers work on the same principle as their monochrome cousins. However, they also include three other toner cartridges: cyan, yellow, and magenta. It's the toner from the four cartridges combined that allows the laser printer to print in full color.

A big drawback with laser printers is that they can only use a limited range of paper types. Since the printing process involves heat, paper with a plastic or resin coating cannot be used without risking damage to the printer. Although the print from modern color laser printers is very high quality it is not considered to be photo-quality. Laser printers are excellent for creating proof documents for checking, but less suitable for making exhibition-ready photographic prints.

CANON LBP5975
A4 color laser printer.

Image © Canon

Dye-sublimation

Dye-sublimation printers use heating elements in a print head to transfer dye onto the surface of the medium being printed to. The dye is stored as a solid on a long cellophane ribbon comprising three colored panels—cyan, magenta, and yellow—followed by a protective overcoat. This type of ribbon is often referred to as CMYO. The panels are the same size as the material being printed on, so to create a 10 x 12in. (25 x 30cm) print the ribbon would need to be at least 10in. (25cm) wide by 48in. (1.2m) long (four panels, 12in. in length). However, most ribbons are longer to allow a number of prints to be made before a replacement ribbon is required.

When an image is printed, the first of the colored panels and the medium being printed to are aligned and pass through the printer. During this process the heating elements inside the print head rapidly change temperature to vary the amount of dye being transferred. As the dye is heated up it turns to gas, which solidifies on the medium as it cools.

The medium is then drawn back into the printer and aligned with the next colored panel, and the process repeats. The three colors combined produce the full color image. The final panel—the overcoat—bonds to the medium to form a protective layer. This is partially to protect the print from light scratching, but also to stop the dye from running if exposed to warmth later on.

The main advantage of the dye-sublimation process is that the print is made of a continuous tone (unlike inkjet prints—*see page 14*). This means that prints have the look of a traditional darkroom print.

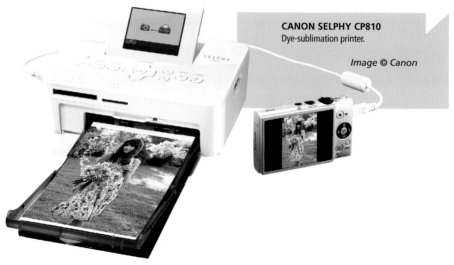

CANON SELPHY CP810
Dye-sublimation printer.

Image © Canon

Another advantage of dye-sublimation printers is that they are very clean. Unlike inkjet printers the dye is never in a liquid form, so there is never any risk of ink spills. A dye-sublimation print is also dry as soon as it is finished—unlike an inkjet print, it can be handled immediately. The final advantage is that it is very easy to calculate the cost of a print, as a ribbon is designed to produce an exact number of prints before it needs to be replaced.

For the creative printer, the big disadvantage is that the media that can be used to print to is limited, particularly in comparison to an inkjet printer. The paper used must have a special coating able to take the dye successfully. This makes dye-sublimation printers unsuitable for printing text documents on standard office paper.

The range of paper sizes that can be used is also limited by the size of ribbons available for a particular dye-sublimation printer model. Dye-sublimation printers are also weak when neutral black and white images are required. This is mainly due to the lack of a black dye panel on a standard CMYO ribbon. However, some dye-sublimation printers—such as the Canon Selphy ES range—do accept black and white (or BWO) ribbons.

Dye-sublimation printers aren't for everyone. Commercially, they are ideal for event photographers who want to sell prints of an event immediately—indeed some dye-sublimation printers can be powered by batteries, making them highly portable. However, if you want the greatest degree of choice when it comes to paper size and quality, inkjets take some beating.

CANON SELPHY CP810
Media tray.

Image © Canon

Inkjet

Think of a printer for creating photo-quality prints and you'll probably picture an inkjet printer. Inkjet printers for home and small-office use have revolutionized photography, allowing the printing of photo-quality imagery at a relatively low cost.

The basic principle of an inkjet printer is fairly straightforward. Paper (or another suitable medium) is fed into the printer using a rotating roller. As the paper passes through the printer, the document being printed is gradually created by a moving print head. The print head squirts tiny amounts of colored ink as it scans backward and forward over the paper. Like color laser printers, inkjet printers use four colors to produce a full color image: cyan, yellow, magenta, and black (some inkjet printers refine this further by adding lighter versions of these four colors for improved color rendition). Each of these colors is held in individual reservoirs, either altogether in one cartridge block or as a series of separate cartridges.

The clever and less straightforward part of an inkjet is the mechanism used to squirt the right amount of ink out onto the paper. There are two technologies commonly used to achieve this. The first method, known as thermal, uses heat to create bubbles within an ink-filled chamber in the print head. These bubbles cause a change in pressure that forces droplets of ink out of the print head and onto the paper. Canon, HP, and Lexmark commonly use this method in their range of inkjet printers (Canon using the name Bubblejet for this reason).

KODAK ESP 3.2
A4 all-in-one printer (scanner, inkjet printer, and copier).

Image © Kodak

Jargon Busting: Giclée

Giclée is a term used to describe a print made on an inkjet printer. The term derives from the French word for nozzle: gicleur. The verb form of gicleur, gicler means to squirt or spray.

The second method, known as piezoelectric, uses piezoelectric material in a chamber inside the print head. When a current is passed through the material it changes shape. This causes a change in pressure within the printer that forces ink droplets out. Epson commonly uses this technology.

Both systems have advantages and disadvantages. Thermal inkjet printers are usually cheaper to produce. However, the ink in a thermal inkjet needs the addition of a volatile compound for the process to work. This compound can cause clogging in print heads.

A slightly underrated aspect of inkjet printers is the precision of their roller mechanisms. The paper must be pulled through the printer extremely precisely to avoid noticeable gaps in the output. And this happens over and over again without fuss. Inkjet printers are astonishing pieces of technology.

The company that produces a particular inkjet printer will also produce the ink cartridges for that printer. This means that the ink will have exactly the right formulation for the print head to work effectively. Some manufacturers, most notably Epson, fit their ink cartridges with microchips. These microchips communicate information about the level of ink in the cartridge to the printer. Once the cartridge is empty the printer will stop working. However, to prevent the user from simply refilling the cartridge, the microchip cannot be reset.

EPSON STYLUS PHOTO R3000
A3+ inkjet printer using Ultrachrome inks.

Image © Seiko Epson

Ink

You won't be surprised to learn that your inkjet printer uses ink to create a print. However, there's more to the story than that. There are two types of inks currently used by inkjet manufacturers: Dye and pigment. Both have advantages and disadvantages, so there's no clear winner between the two.

Dyes

A dye is a colored substance that is either a liquid or is soluble in liquid (water is most often used as a base in which to dilute a dye). When applied to a material (such as cloth or paper) the dye alters the color of the material either temporarily (dyes can be washed away) or permanently (when fixed using a mordant). Dyes were originally derived from natural substances such as plants. Think of the way that the juice from berries stains clothing—a natural dye in action. However, today most commercial dyes are created synthetically using industrial processes.

Using dyes to create the ink for an inkjet printer has a number of advantages. Dyes are inexpensive, so reducing the cost of creating inks. Dyes are also vibrant in color, which

means that highly saturated prints can be made reasonably easily. However, dyes aren't particularly lightfast. A print made using dye-based ink is prone to fading even over relatively short periods of time. That said, technology moves on and modern dye-based inks are much improved compared to those from ten or even five years ago.

Jargon Busting: Lightfast

Light is destructive over time, causing damage to visual media such as paint and photographic images. This is typically seen as a reduction in the saturation of colors and the lowering of contrast. Taken to the extreme this could even mean the loss of the image entirely. The more lightfast an image, the greater it is able to resist this damage. Images that are not lightfast should be kept out of direct sunlight and in extreme cases only viewed under a subdued light source.

KODAK INKS
Complete dye ink set.

Image © Kodak

Pigment

A pigment is a colored particulate substance that isn't soluble in liquid. Instead, the particles of pigment are held in suspension by the liquid (again, this is most often water). Pigments aren't absorbed by material in the way that a dye is. Instead the pigments sit on the surface of the material.

Pigments are far more lightfast than dyes. They are an archival product, retaining their color over long periods of time. A print created using pigment ink should potentially last one to two-hundred years without fading (when using archive-grade paper and when displayed under reasonable light levels).

However, dye-based printers are still being manufactured, so if pigment inks are so good, why don't all printers use them? Pigment inks have their drawbacks. For a start, they are more expensive to produce than dye-based inks. Nor are pigments as vibrant as dyes—though again technology continually develops and modern pigment inks are far superior to those from even a few years ago. Pigments can also create problems with print heads—the particles in the ink can bond together and clog the print head nozzles if a printer isn't used regularly.

The prints from early pigment-based printers also suffered from a visual effect known as metameric failure (more often, and inaccurately, referred to as metamerism). A print that appears to shift color under different light sources suffers from metameric failure. For example, a cool gray under daylight-balanced lighting may appear to be a warm gray under tungsten lighting. Again, ink technology has improved and metameric failure is not the problem it once was.

Note

Printer manufacturers use proprietary names for their pigment-based inks. Epson currently uses Ultrachrome (with Ultrachrome K3 being the latest variant) and Canon use Lucia. Slightly confusingly HP use Vivera for both their dye and pigment-based inks.

EPSON STYLUS PRO R3880
A2 printer, with full pigment ink set installed.

Image © Seiko Epson

Matte and photo black

All inkjet printers use a black ink cartridge. However, some inkjet printers require the fitting of either a photo black or matte black cartridge depending on the type of paper you use. This is because the ink in these cartridges is optimized for a particular finish on the paper. Photo black is required when printing on gloss or semigloss papers. Matte black is required when printing to matte, watercolor, or cotton rag papers. If the wrong cartridge is used with the wrong paper, the blacks in the print will look flat and have a slightly different reflectivity to the other colors in the print.

Older printers do not generally have space for both cartridges to be fitted simultaneously, so if you swap paper types you need to swap the cartridges over as well. Each time you do this the printer will have to perform a cleaning cycle to flush out the old ink from the print head. This wastes a lot of ink, and so discourages swapping paper types too often.

More recent printers tend to have space for both types of black cartridge, which is far more efficient in terms of saving ink. The cartridge used is set automatically after the media type is selected when setting the printing options for an image.

EPSON STYLUS PHOTO R3000
A3+ printer, with both a Photo Black (PK) and Matte Black (MK) cartridge installed.

Image © Seiko Epson

Droplets of ink

The concept that inkjet printers squirt droplets of ink onto paper is a very simplified explanation of what happens when a print is made. The droplets of ink are extremely small, typically between 50 and 60 microns in diameter (as a comparison, a human hair is approximately 70 microns in diameter). Because droplets of ink are used, inkjet printers can't print continuous tones in the way that dye-sublimation printers can. Instead, it is the extremely small size of the individual dots bunched together that conveys the illusion of continuous tone.

As previously mentioned, printers use four basic ink colors: cyan, magenta, yellow, and black. These four inks can be used to create a full color print by a process known as dithering.

Dithering is a technique where the printer adjusts the sizing and spacing of the individual droplets of ink. By dithering the colored inks in the right proportions, the eye is fooled into seeing a full range of colors. It is only when the print is looked at microscopically that it's possible to see how the trick is done.

One way to assess the capabilities of a printer is to look at its maximum dpi value. Dpi stands for dots per inch and is a measure of how many individual droplets of ink a printer can print across one inch of paper.

RESOLUTION
Modern inkjet printers are extremely high resolution. Canon's Pixma Pro-1 has a resolution of 4800 x 2400 dpi.

Image © Canon

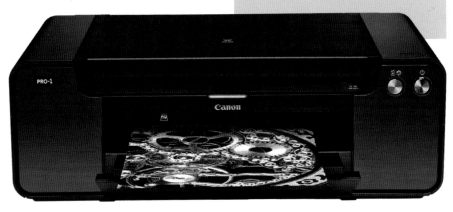

The higher the dpi value, the finer the droplets of ink and the sharper the final print. The dpi value is therefore the resolution of the printer (dpi is subtly different to ppi, which is discussed in chapter 4. Dpi should only ever be applied to printers).

Usually printers can print an equal number of dots vertically as well as horizontally. If a printer is shown as having a maximum dpi of 600, it's usually fair to assume that this means for every square inch of paper 600 x 600 dots will be printed. If a printer has a higher resolution in one axis compared to the other, two figures are usually shown (4800 x 2400 dpi for example).

However, just because a printer has a high maximum dpi doesn't mean that it has to use its capabilities to the full every time a document or image is printed. Printers will typically lower their dpi when printing out in draft or normal mode in order to conserve ink.

The maximum dpi of a printer also only tells part of the story. The type of paper you use will affect the sharpness of the final print. Gloss paper suffers less from dot gain (see below) than matte paper, and so prints will look far sharper on this type of paper.

Jargon Busting: dot gain

Ink is wet. When it is applied to paper it spreads slightly through the fibers of the paper. This spreading is known as dot gain.

CMYK
This book is printed in a different, but related, way to prints made with an inkjet printer. Cyan, magenta, yellow, and black dots (left) are used to build up the full color images you see on the page (right).

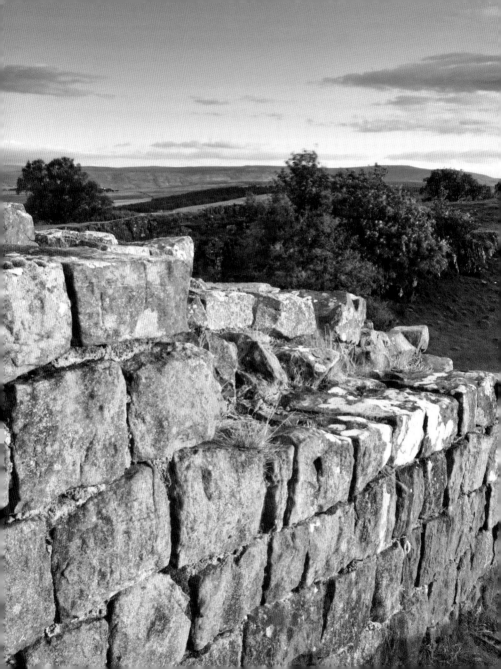

Communications

Generally, printers need to be connected to a PC in order to receive the digital data that will be printed out either as a page of text or as an image. This connection can either be physical (via a USB cable) or over a Wi-Fi connection. In order to communicate successfully with a printer, a printer driver must first be installed on your PC. A printer driver is a piece of software that controls the printing process, converting the digital data of the file being printed into the form required by the printer. When you buy a printer, the driver is usually included on a CD-ROM. However, increasingly printer drivers are available online from manufacturers' web sites. It's a good idea to check occasionally whether the driver for your printer has been updated. The Windows and Mac operating systems also support most popular printers natively.

Some printers don't necessarily require a PC connection to print images. These printers are known as PictBridge printers. A PictBridge printer can be connected directly to a compatible digital camera either via a USB cable or by inserting the camera's memory card into a slot on the printer. It's a very immediate way

to print images, though there's generally little scope to adjust the image on the memory card to correct for aspects such as contrast or color saturation.

A related concept is DPOF, or Digital Print Order Format. This is a function that is available on a wide range of cameras. It is essentially an editable list saved to the camera's memory card that specifies what images—and in what quantity—will be printed. A compatible printer can then use this information to automate the printing process when the camera or memory card is connected to it.

> ### Note
> Typically RAW files are not supported by PictBridge or DPOF.

CANON PIXMA PRO-1
A PictBridge compatible inkjet printer.

Image © Canon

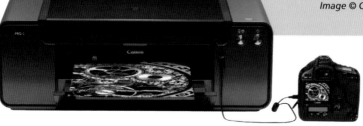

Printer manufacturers

Canon

Canon specializes in consumer and specialist imaging products. The company is most famous for its range of cameras, but is also a leading manufacturer of printers. The Canon range currently includes dye-sublimation, laser, and inkjet printer models.

Dell

Dell is probably better known as the manufacturer of desktop and laptop Windows PCs. However, they also produce a range of all inkjet and laser printers, often offered as part of a bundle with the company's PC products. Dell's inkjet printers are currently "all-in-one" devices featuring printer, scanner, and copier.

Epson

Epson (or the Seiko Epson Corporation) is the world's largest manufacturer of printers, both for home and office use. The current range includes dot matrix, laser, and inkjet printers.

Hewlett Packard

HP, as it is now more widely known, is a US-based company specializing in digital technology products. The HP range of printers is highly regarded and features both laser and inkjet models.

Lexmark

Lexmark is a relative newcomer, formed in 1991 from the leveraged buyout of IBM's printer division. Lexmark currently manufacturers dot matrix, laser, and inkjet printers.

Oki

Oki is a Japanese multinational corporation that supplies dot matrix and laser printers to the domestic and professional market.

Panasonic

Panasonic is a consumer-electronics giant that produces cameras for the Micro Four Thirds system. The Panasonic printer range includes dot matrix and laser models.

Samsung

Like Panasonic, Samsung is a consumer-electronics giant. The company manufactures compact and system cameras. The Samsung printer range includes monochrome and color laser models.

Xerox

The name Xerox is synonymous with photocopiers. However, the company also produces high-end monochrome and color laser printers.

Continuous ink systems

Keeping an inkjet printer supplied with ink can be an eyewateringly expensive process. A popular solution to this problem has been the installation of a continuous ink system (or CIS). These are made not by the printer manufacturers but by third-party companies. A CIS replaces the manufacturer's ink cartridges with new cartridges that are connected to bottles of ink by long, flexible tubes. The bottles can be continuously topped up so that you never run short of ink. The bottles hold far more ink than the original cartridges so ink is bought in bulk. This substantially reduces the cost of the ink. Lyson is probably the best-known maker of a CIS product, though there are different systems to choose from.

There is a big drawback to using CIS however. When you install a CIS, you are essentially modifying your printer. This will make your warranty invalid. It's therefore not a good idea to install a CIS product if your printer is still under warranty.

A slightly less worrying drawback is that the ink in a CIS is not the same ink that will have been used in the printer's original cartridges. This means that you will need new profiles for the paper you use regularly. Fortunately, profiles for popular papers will generally be available from the web site of the CIS manufacturer. If you use a more obscure type of paper you may need to create a bespoke profile. Manufacturers such as Lyson usually also produce their own range of papers and will supply profiles free of charge for these products.

Note

Not every printer will have a compatible CIS product. The most popular printers by Epson, Canon, and HP are usually supported, though these will not be the most up-to-date models in the respective range.

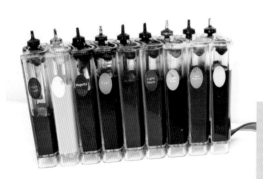

CIS INKS
The ink set for a CIS system fitted to an Epson R2400 printer.

Other processes

You don't need to own a printer to make digital images. You could take your images to a traditional photo lab or online vendor instead. This approach has much to recommend it. There is no large initial cost associated with buying a printer or with long-term running costs in the form of paper and ink. The drawback is of course that you won't have the same level of control over the type of paper used.

Prints produced in a lab are often true photographic prints rather than inkjet prints. This type of print is known as a C-type print, the C standing for Chromogenic. In a C-type print the digital image is projected onto light-sensitive paper. The paper is then fed through a series of chemical baths to develop and fix the print. C-type prints are very archival and with care should rival the very best inkjet prints for longevity.

One big advantage of having prints made in a lab is that prints can be made much larger than with a domestic inkjet. Large processing labs equipped with LightJet or Durst Lambda C-type machines will be able to produce prints up to 50in. (130cm) across. When supplying digital files to a lab, it's recommended that you use the sRGB color space *(see chapter 2)*. The lab should also be able to advise you what ppi settings to use *(see chapter 4)*.

KODAK PICTURE KIOSK
The system used in many photo labs.

Image © Kodak

CHAPTER 2 PRINT MEDIA

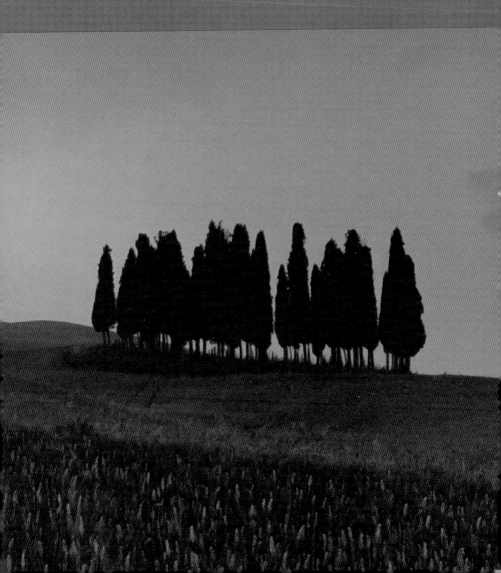

Print media

Preparing an image for printing involves a number of creative choices. And those creative choices don't end when you switch on your printer.

Choices

You have a printer, so now you need something to print on. The most obvious and easily obtainable print media is paper. However, there are many different kinds of paper, some more suitable to certain printing tasks than others. The type of paper you use is also an aesthetic—and therefore very personal—choice.

Other issues you need to consider are more technical. As mentioned in the previous chapter there are two types of inks currently used by inkjet printer manufacturers. Some papers are suitable for both types; other papers are only suitable for one or the other. The size of your printer will also determine the maximum size

of the paper you can use. However, there are some inkjet printers that can use roll paper. Although your printer will still restrict the width of a print, the length would be limited only by the size of the roll—or even the amount of ink in the printer's cartridges!

You don't necessarily need to print on paper, either. If you're using an inkjet printer there are other media options that are worth exploring. Some of these are described in this chapter. Also in this chapter is information about the various types of papers available. Hopefully by the time you reach the end you'll realise that printing is as much a creative act as creating the image in the first place.

FINISH *(Opposite)*
Paper is available in a number of different textures and finishes. Which you use is very much a personal choice.

PAPER
Paper comes in many forms, some more suitable for printing to than others!

Paper

Think of making a print and it's almost certain that you'll think of using paper to do so. Paper is a ubiquitous product. Not so long ago it was thought that digital technology would reduce the need for paper; the "paperless" office is a phrase that was once thrown about quite freely. Instead, we use more paper than ever before, with the popularity of home printing being one of the contributing factors.

Paper was invented in China almost two thousand years ago. Over the centuries the use of paper slowly spread west until the middle ages. The invention that dramatically increased the need for paper was the movable-type printing press, invented by Johannes Gutenburg in Mainz, Germany during the 1430s. The ability to cheaply print books, leaflets, and posters led to the manufacture of paper becoming an industrial rather than a smallscale business. Remarkably, there are a few companies from this period still making paper today.

Paper is freely available and comes in a wide variety of sizes, weights, and finishes. Most printer manufacturers produce paper designed specifically for use with their printers, often supplying profiles for those papers free of charge. However, you don't need to stick with the paper made by your printer manufacturer. There is a bewildering range of printer paper available from third-party manufacturers ranging from everyday gloss paper to specialist archival fine-art papers. If you have a popular printer model it's often possible to find suitable profiles made by the third-party paper manufacturers on their web sites. Throughout this book are lists—by no means exhaustive—of paper manufacturers and their product ranges.

PAPER
The type of paper you print on often depends on the style of the image.

Canvas

An inkjet printer doesn't use heat to bond ink to a surface, so this expands the range of media that can be used. A popular way to display images is on canvas. Until relatively recently this was only possible using commercial offset printing. However, this is an expensive process only suitable when large numbers of a particular print are required. A more bespoke service was only made possible through the widespread availability of inkjet and, to a lesser extent, dye-sublimation printers.

There is now a wide choice of companies that will print and finish individual canvas prints relatively cheaply, but there's no reason not to print on canvas at home. Unfortunately, not all printers can print to canvas so the first step is to check whether your printer can. Printing to canvas is generally more effective with pigment-ink printers than those that use dye-inks. A big difference between canvas and paper is that canvas must be kept taut once the image has been printed. This is usually achieved by stretching it tightly over a wooden frame. The frame prevents the canvas from sagging and also allows the image to be fixed to a wall.

Film

Inkjet printers can also be used to print to inkjet-compatible transparent film (this is film with one side slightly roughened so that the ink can bond to the surface). This has many uses, from creating images that can be backlit to printing large-format negatives that can be used to make contact prints in a darkroom.

CANVAS
Canvas has a very distinctive regular texture.

The qualities of paper

Walk into any stationery store and you'll be presented with a bewildering choice of paper. It's often difficult to know where to start. However, your choice is made far easier once you understand how the physical qualities of paper will affect an image printed on it.

YELLOWING
The text pages of this twenty-year old book are noticeably yellowing, particularly when compared to the better quality paper used for the color image inserts.

The raw ingredients
Paper is made from fibers that have been soaked in water to form a slurry-like mix. The simplest method used to create paper is to pour this mix into a mould so that a thin, even layer is formed. The base of the mould is a mesh screen, which allows most of the water to drain away. The damp, fibrous layer is then placed on a felt sheet. This is pressed to squeeze out the last of the water and to flatten the paper.

There are two types of fibers commonly used to make paper today. The first type is derived from wood pulp, typically from softwood trees such as fir or pine. This is a very cheap material and is used in the production of paper used for printing newspapers and books. The big problem with paper made from wood pulp is the presence of a chemical compound called lignin. A paper that is not lignin-free will deteriorate over time, becoming yellow and brittle. If you keep old newspapers you will have seen the effect. It is possible to treat wood pulp paper to reduce or remove the lignin, though this does add to the cost.

Jargon Busting: Alpha cellulose
A paper defined as alpha cellulose is paper made from wood pulp but that has been chemically treated to remove the lignin. The result is a more stable paper, but one that isn't truly archival until other potential problems such as the paper's alkalinity have been addressed.

The second type of fiber used to make paper is derived from the cotton plant (originally the fibers came from old cotton rags, which is why cotton-derived paper is known as cotton rag). Cotton is a far more expensive product than wood pulp. However, rag paper does not deteriorate over time in the way that wood pulp paper does and is considered an archival product.

This is because rag paper is naturally lignin free. Cotton fibers are longer than wood pulp fibers and so the resulting paper is also stronger. Rag paper is often a mix of different types of materials. This mix is often shown as a percentage, either in the manufacturer's specifications or as a watermark on the paper itself.

Paper weight and opacity

The thickness of a sheet of paper is shown as its weight. This is measured in either grams per square meter (referred to as the grammage, gsm, or g/m²) or as pounds per ream (the ream weight or lb)—the former used internationally, the latter mainly in the USA.

The heavier a paper, the thicker it is. Generally heavier papers are able to absorb more ink without buckling, though this is at the cost of flexibility. If a paper is too heavy it will no longer be flexible enough to be fed around the roller in a printer. Some inkjet printers have rear feeders allowing thicker paper to be fed straight through without bending. Paper used for printing documents typically has a weight of 90g/m² or 24lb. The weight of photo-quality paper does vary,

> ### Notes
> *Paper weight is also known as paper density.*
>
> *Bamboo is another material used to make paper. Though less common than wood pulp or cotton rag, bamboo is highly regarded as a paper.*

HEAVY
Watercolor paper is a very heavyweight paper designed to have stop water absorption and prevent "cockling."

though 175g/m² or 65lb is probably the lightest that should be considered for prints that you wish to display.

Paper is also measured by its opacity. The opacity of a paper is determined by how much light is transmitted through it. Paper such as tissue paper has a very low opacity, whereas thicker material such as cardboard has a very high opacity. The opacity of a paper is shown as a percentage of the amount of light that is blocked by the paper. A paper with an opacity rating of 96% would therefore absorb or reflect all but 4% of any light shone through it.

A high opacity rating is important if you intend to print on both sides of a paper—if you were creating a handmade book for example. However, you would need to use a paper with a lower opacity if you intended to print images that would be displayed with backlighting.

Paper sizes

Paper is also sold in set sizes. There are two size systems that are commonly used today, the ISO 216 standard and the North American ANSI system. The ISO 216 standard is used internationally; the North American letter system is used only in North America and in countries such as the Philippines.

The ISO 216 standard uses the letter A followed by a number to define the size of the paper. The largest ISO standard size is A0, which is 841 x 1189mm. The next largest is A1, which is created by halving A0 along the longer side to create a sheet that is 594 x 841mm. The size of each successively smaller sheet in the series is derived this way. So A2 is half the size of A1 and a quarter of the size of A0, but twice the size of A3 and so on. The smallest ISO standard paper is A10, which is a miniscule 26 x 37mm. Each size from A0 to A10 has the same width to height proportions of 1:1.41.

"A" SERIES
Happily the 3:2 aspect ratio of DSLRs is a reasonable match to the ratio of the ISO 216 standard.

An interesting anomaly is the A3+ or Super A3 size. This is a paper size not recognized by the ISO 216 standard. However, it is now a widely accepted size, supported by printer and paper manufacturers such as Epson. Indeed, many printers are now sold on the basis of being A3+ compatible.

Paper format	Size (mm)	Size (inches)
A0	841 × 1189	33.11 × 46.81
A1	594 × 841	23.39 × 33.11
A2	420 × 594	16.54 × 23.39
A3+	330 × 483	13 × 19
A3	297 × 420	11.69 × 16.54
A4	210 × 297	8.27 × 11.69
A5	148 × 210	5.83 × 8.27
A6	105 × 148	4.13 × 5.83
A7	74 × 105	2.91 × 4.13
A8	52 × 74	2.05 × 2.91
A9	37 × 52	1.46 × 2.05
A10	26 × 37	1.02 × 1.46

CANON PIXMA IX6550
A3+ inkjet printer.
Image © Canon

The ANSI system is based around the standard North American Letter size of 8½ x 11 inches (or ANSI A, roughly equivalent to A4). Unlike the ISO 216 standard, a single letter (starting with A and ending with E), defines the different sizes in the series. The ANSI series also differs from the ISO 216 standard in that the aspect ratio is not constant through the series. It alternates between 1:1.29 (so that the height of the paper is 1.29 times longer than the width) and 1:1.54 (when the height of the paper is 1.54 times longer than the width).

Paper format	Size (mm)	Size (inches)	Aspect Ratio
ANSI A	216 × 279	8½ × 11	1:1.29
ANSI B	279 × 432	11 × 17	1: 1.54
ANSI C	432 × 559	17 × 22	1:1.29
ANSI D	559 × 864	22 × 34	1: 1.54
ANSI E	864 × 1118	34 × 44	1:1.29

Note
When ANSI B is used vertically it is also referred to as Ledger, when used horizontally (as in the diagram) it is also known as Tabloid.

ANSI
The proportions of the ANSI sizes compared.

Photo paper

In the predigital days there was only one type of photo paper. This was paper coated with a light-sensitive emulsion of silver-halide salts that could be used to make prints by projecting light through a negative onto the paper. The image was then developed and fixed by washing the paper in a series of chemical baths. Digital photo paper shares many of the qualities of darkroom photo paper with one important difference: it is not light sensitive.

One of the problems with printing an image on standard office paper is the absorbency of this type of paper. Ink, being a liquid, spreads easily through the fibers of office paper, resulting in muddied colors and a reduction in sharpness. The most important characteristic of digital photo paper (from here on referred to as photo paper) is how the surface holds ink.

Paper designed specifically for the printing of images has a special coating on the surface. This coating is known as the ink receptor coating (IRC) and usually has a micro-ceramic based coating. There are two technologies currently used: polymer-type and particle-type coatings. The two technologies have their advantages and disadvantages.

The polymer-type is a relatively inexpensive process and is therefore used for cheaper types of photo paper. Its one big advantage

Note

Unfortunately most manufacturers don't specify the coating type used for a particular paper. As a rough-and-ready rule, a paper advertised as quick drying probably uses a particle-type layer. Paper that feels slightly tacky to the touch probably has a polymer-type layer.

CLEARER
Using an inkjet printer the same text was printed onto two different types of paper, one uncoated (left) the other coated (right). The text on the uncoated paper is far less sharp because of ink spread.

is that it is reasonably scratch resistant. However, very little ink is absorbed with this coating, so the resulting image appears to sit on the surface. The ink will take longer to dry and can feel sticky several hours or even days after printing.

The particle-type has an opposite set of advantages and disadvantages. It is a costly process so the resulting paper is generally expensive. The surface is less durable, though it is more waterproof. The ink dries almost instantaneously, and image quality is generally higher than a paper with a polymer-type coating.

Finish

The coating on photo paper can be have a gloss, semigloss, or matte finish. The one you select is very much a personal choice. Gloss is by far the most popular type of paper, partly because the finish is very similar to a traditional darkroom print. The surface of gloss paper is generally durable and resistant to damage caused by handling. Contrast and the saturation of colors is higher on gloss paper compared to semigloss or matte paper. The latter factor is due to the fact that gloss paper has a relatively high color gamut compared to semigloss or matte paper.

Another advantage of gloss paper is that an image will appear sharper, particularly in comparison to matte. However, gloss paper is reflective, and in the wrong light it can be difficult to see an image that has been printed on it. There is also an argument that gloss paper lacks subtlety: for some subjects it can appear too strident, too slick and glossy.

Notes

Semigloss can also be known as satin, silk, eggshell, oyster, or luster, depending on the paper manufacturer.

Most gloss and semigloss papers only have a coating on one side of the paper.

LIGHT
Gloss prints are highly reflective. Ideally they should be displayed away from point light sources.

A reasonable compromise is semigloss paper. This is less reflective than gloss paper and also has a lower apparent contrast and color range. Semigloss paper therefore lacks some of gloss paper's punch. However, if you intend to produce prints that will be displayed under difficult lighting conditions, semigloss paper is a useful choice.

Matte paper is non-reflective, which makes this type of paper ideal when prints need to be displayed in rooms where there are numerous point light sources—though of course, putting a print made on matte paper behind glass will negate this advantage. Matte paper absorbs more ink than gloss paper, so images do look slightly softer in comparison. Color and contrast is also lower. Another disadvantage of matte paper is that the surface is more easily damaged by handling. However, matte paper is worth considering for images that require a more subtle approach.

Paper brightness

The brightness of a paper is a measurement of how much light is reflected from the surface using a standard testing procedure. As with most paper-related issues there are two standards: the ISO Brightness standard used internationally, and the TAPPI Brightness scale used in the USA.

Unfortunately the two systems use slightly different methods of testing so it is not possible to produce an exact comparison. Essentially both systems measure the amount of light reflected by paper as a percentage. Paper is naturally yellow in color. The higher the percentage, the brighter and whiter the paper will appear.

However, paper can be made to appear brighter and whiter by the use of fluorescent

Note

If you use paper that contains FWAs and OBAs it is important not to frame the resulting print behind glass that reflects UV light. FWAs and OBAs are only activated by UV light and so their effectiveness will be reduced considerably behind UV resistant glass.

WHITE
This range of papers shows how different "white" can be.

whitening agents (FWAs) or optical brightening agents (OBAs). FWAs and OBAs are dyes that work by absorbing light from the ultraviolet end of the spectrum and re-emmiting it as visible light biased toward the blue end of the spectrum. It is this blueness that makes paper appear whiter.

One problem with the use of FWAs and OBAs is that their effectiveness can fade over time, so making the paper appear more yellow (essentially its original color). Paper that contains FWAs and OBAs will also appear more yellow when viewed under lighting that contains little or no UV light. One final problem with this type of paper is that there are good indications that it will be less archival than FWA and OBA-free paper. Sometimes brightness isn't everything.

Texture

The surface of paper can be perfectly smooth or it can be textured. As a general rule, gloss photo paper is either smooth or subtly textured, while matte paper can be smooth, slightly textured, or heavily textured. As with most aspects of photography and printing, the choice of which you use is very personal. However, images will invariably look softer on textured paper. Another potential problem with textured paper—particularly if it has not been designed specifically for printing purposes—is that dust from the paper may cause damage to print heads, and the paper may jam the printer.

TEXTURE
The textures of these two papers are very different and this would be reflected in how detail is perceived in a print.

Camera: Canon EOS 7D
Lens: 12mm lens
Exposure: 6 sec. at f/13
ISO: 100

SOFT
The choice of media you use to create a print often depends on the subject. This long-exposure black-and-white image has a soft quality. To me, this makes it ideal for printing on matte paper or even onto canvas.

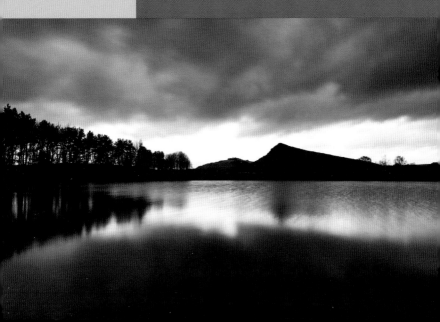

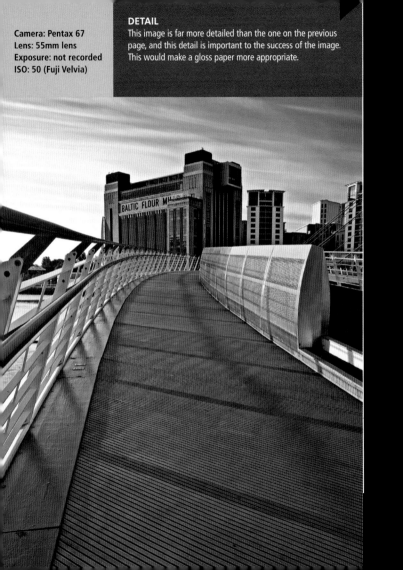

Camera: Pentax 67
Lens: 55mm lens
Exposure: not recorded
ISO: 50 (Fuji Velvia)

DETAIL
This image is far more detailed than the one on the previous page, and this detail is important to the success of the image. This would make a gloss paper more appropriate.

Other terms

Apart from the basic terms covered so far there are other terms that you will come across less frequently.

Baryta paper

Baryta is a clay-like chemical compound—barium sulphate—that is applied below the emulsion of traditional black-and-white fiber-based photo paper. The Baryta layer helps to make the paper whiter than it would otherwise be. Relatively recently it has also been used to produce fine-art digital photo paper. This paper is designed for use only with pigment ink printers. The use of Baryta has helped to create a photo paper that marries the aesthetic appeal of matte paper with the ability to use photo black inks for increased tonal range.

Watercolor paper

Watercolor paper is a matte paper with a slightly rough texture. As the name suggests it was originally developed for artists who paint with watercolors. However, it is a popular paper to use for printing. The resulting soft feel of a print on watercolor paper is ideal for certain types of imagery. Coated watercolor paper is now available expressly for use with inkjet printers.

Calendered paper

Paper that has been calendered has been passed between two heavy metal rollers to produce a very smooth surface—far smoother than non-calendered paper.

Resin coated

The term originally applied to darkroom photo paper that had the paper base sandwiched between two polyethylene layers. This reduced the time needed to wash the developing chemicals away, compared to traditional fiber-based papers. Some digital photo papers are resin coated today to increase the glossiness of the paper.

CANSON INFINITY BARYTA PAPER

Image © Canson

Paper problems

Photo paper is reasonably robust, but that doesn't mean that you should be careless with it. There are many things that you can do to paper that will reduce the quality of the prints you make.

Moisture

If paper is stored in a damp environment it will absorb moisture. This can cause the paper to cockle (so that it is no longer flat). Even if the paper appears undamaged, moisture will affect how ink is absorbed by the paper leading to inconsistent printing. Always keep paper in a dry place with less than 60% humidity, preferably in the box or packet it was sold in.

Dust

Another good reason to keep paper in the original packaging is dust. Dust on paper will cause problems during printing. If the dust falls off after a print has been made it will leave white specks on your print. It can also contribute to print head clogging. Some paper, particularly watercolor paper, is naturally "dusty." Before you begin printing, it is worth using a blower or soft brush to clean the paper.

Fingerprints

No matter how often you wash your hands, your fingers will be slightly greasy. Grease leaves a mark on paper, particularly on gloss paper. The oils in the grease are also slightly acidic. The simplest method to prevent leaving fingerprints is to hold only the edges of the paper. A far better method is to wear cotton gloves while handling the paper. These gloves are generally available at most good art stores.

FINGER MARKS
Not the kind of print you
want to make.

Age

Like food, some papers have a "best before date." This should be shown clearly on the original packaging. Paper that has expired may still be usable, but it is safer to use it for proofing only rather than to create prints that you want to keep.

Coating

Photo paper is generally only coated on one side and this is the side that should be printed to. Some paper manufacturers make things easy by printing their logo on the non-coated side. It is also easy to decide which is the coated side when using gloss or semigloss paper—the non-coated side will be far less glossy. However, matte paper is much more tricky. If the paper is

textured, the coated side will generally have a slighter heavier texture. If you are using smooth matte paper, use a fingernail to score a small line lightly near the edge of the paper. The line will be more visible on the coated side than on the non-coated side.

Weight

Heavyweight papers don't bend easily, so you may find that your printer won't be able to pull them around the rollers. The maximum weight paper your printer can handle should be in its specification list. Some printers have a rear sheet feeder that allows the use of heavyweight papers. The procedure to do this should be explained in the manual bundled with the printer.

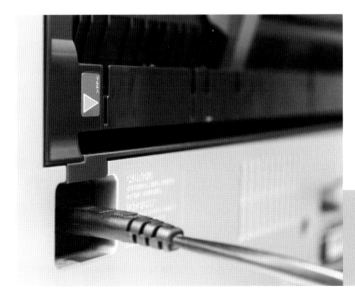

PRINTERS
Rear sheet feeders are invaluable if you want to use heavyweight paper.

Paper profile: Hahnemühle

In February 1584, the Relliehäusische Papiermühle was established by Merten Spieß. Spieß's paper mill was built on a river in Relliehausen near Dassel, in what is now Lower Saxony in Germany. The source of the river is the nearby Solling hills, and it was the action of the sandstone in filtering and softening the water that allowed Spieß to produce high-quality paper.

The paper mill was owned by the Spieß family until 1769, when it was sold to Peter Johann Jacob Heinrich Andrae. The Andrae family then ran the mill for the rest of the century and most of the 19th century. In 1883, paper from the mill was shown at the International Paper Exhibition in Vienna. The following year, Oskar Andrae sold the mill to H.J. Heinemann of Hanover. Heinemann began the construction of a new paper production plant, but the company was sold in 1886 before it was completed. The buyer was Carl Hahne and it is Hahne's family name under which the present company still trades today.

Hahnemühle is still based in Dassel, though there are additional offices located in the United Kingdom, France, US, and China employing 150 people worldwide. Hahnemühle is renowned for its fine-art papers, supplied to artists for centuries. The Digital FineArt Collection is a range of inkjet papers derived from Hahnemühle's fine-art papers. The inkjet papers have been finished and coated so that they are optimized to the demands of digital printing.

HAHNEMÜHLE FINE ART PAPER

Image © Hamelin Group

Manufacturer	Paper name	Description
Hahnemühle www.hahnemuehle.com	Rice Paper	100g/m² • alpha cellulose • OBA & acid-free • matte • fine-art
	Photo Rag	188, 308, & 500g/m² • 100% cotton rag • acid-free • matte
	Photo Rag Book & Album	220g/m² • 100% cotton rag • acid-free • double-sided • matte
	Photo Rag Duo	276g/m² • 100% cotton rag • acid-free • double-sided • matte
	Bamboo	290g/m² • 90% bamboo fiber/10% cotton rag • natural white • OBA & acid-free • matte
	Photo Rag Ultra Smooth	305g/m² • 100% cotton rag • acid-free • white • matte
	Photo Rag Bright White	310g/m² • 100% cotton rag • acid-free • bright white • matte
	William Turner	190 & 310g/m² • 100% cotton rag • acid-free • white • matte • watercolor paper texture
	Albrecht Dürer	210g/m² • 50% cotton rag/50% alpha cellulose • acid-free • natural white • matte • distinctive texture
	Torchon	285g/m² • alpha cellulose • acid-free • bright white • matte
	Sugar Cane	300g/m² • 75% bagasse fiber/25% cotton rag • acid-free • natural white • matte
	German Etching	310g/m² • alpha cellulose • acid-free • natural white • matte

Note
Unless otherwise stated, it is safe to assume that a paper will be compatible with both dye and pigment ink printers.

Manufacturer	Paper name	Description
Hahnemühle	Museum Etching	350g/m² • 100% cotton • OBA & acid-free • natural white • matte
	Fine Art Pearl	285g/m² • alpha cellulose • acid-free • bright-white • semigloss
	Photo Rag Satin	310g/m² • 100% cotton rag • acid-free • white • satin
	Photo Rag Baryta	315g/m² • 100% cotton rag • acid-free • white • Baryta
	Photo Rag Pearl	320g/m² • 100% cotton rag • acid-free • natural white • semigloss
	Fine Art Baryta	325g/m² • alpha cellulose • bright-white • high gloss • Baryta
	Baryta FB	350g/m² • alpha cellulose • bright-white • high gloss • Baryta
	Canvas Artist	340g/m² • poly-cotton • acid-free • bright white • matte • canvas
	Goya Canvas	340g/m² • poly-cotton • acid-free • natural white • semigloss • canvas
	Leonardo Canvas	390g/m² • poly-cotton • acid-free • white • high gloss • canvas
	Daguerre Canvas	400g/m² • poly-cotton • acid-free • bright white • matt • canvas
	Monet Canvas	410g/m² • poly-cotton • acid-free • white • matt • canvas

BALANCED *(Opposite)*
A successful print starts with a well-balanced—in terms of color and contrast—digital image.

Canon EOS 5D, 100mm lens, 1/100 sec. at f/8, ISO 100

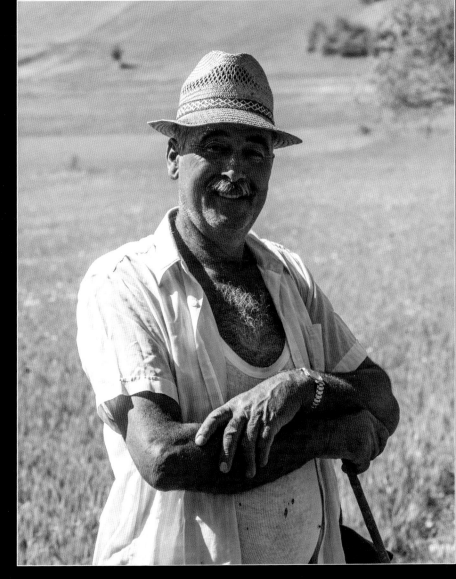

Paper Profile: Canson

Here's a question. What do hot-air balloons and fine-art photo paper have in common? The link between the two is the French paper-manufacturing firm Canson. The origins of the company date back to 1557 and the move from Auvergne to the Beaujolais area of Jean Mongolfier. Mongolfier came from a family of paper makers.

In 1692, Montgolfier's descendants Michel and Raymond Mongolfier arrived in Vidalon, where Antoine Chelle owned the Vidalon Paper Mill. A year later, the two brothers married two of Chelle's daughters, Françoise and Marguerite. Over the course of the next one hundred years the Montgolfier family introduced many technical innovations that improved the paper-making process. In 1784 the paper mill was granted the title "Manufacture Royale" by Louis XVI for the quality of the paper being produced. And for the flight in 1782 of the world's first hot-air balloon by Joseph-Michel and Jacques-Étienne Montgolfier, the balloon was made from paper produced by the Montgolfier paper mill! The Canson logo today features a stylized representation of a hot-air balloon for that very reason.

In 1799 Alexandrine Montgolfier married Barthélémy de Canson, and in 1801 the paper company was renamed Montgolfier et Canson. During the 19th and 20th centuries many artists used Montgolfier et Canson's papers including Joan Miró, Edgar Degas, and Marc Chagall. The company also patented an improvement to the production of photographic paper in 1865. The paper won the Diplôme d'Honneur at the 1892 Exposition Internationale de Photographie. Today Canson Infinity still produce a range of fine-art papers for artists, and now for digital printers with a range of high-quality coated papers specially designed for inkjet inks.

CANSON INFINITY RAG PHOTOGRAPHIQUE

Image © Canson

Manufacturer	Paper name	Description
Canson www.canson-infinity.com	Edition Etching Rag	310g/m² • 100% cotton rag • OBA & acid-free • museum-grade
	Arches Velin Museum Rag	315g/m² • 100% cotton rag • OBA & acid-free • museum-grade
	Arches Velin Museum Rag	250g/m² • 100% cotton rag • OBA & acid-free • museum-grade
	Arches Aquarelle Rag	310g/m² • 100% cotton rag • OBA & acid-free • museum-grade • watercolor paper
	Arches Aquarelle Rag	240g/m² • 100% cotton rag • OBA & acid-free • museum-grade • watercolor paper
	Rag Photographique	310g/m² • 100% cotton rag • OBA & acid-free • museum-grade
	Rag Photographique	210g/m² • 100% cotton rag • OBA & acid-free • museum-grade
	Rag Photographique Duo	220g/m² • 100% cotton rag • OBA & acid-free • museum-grade • double-sided
	Platine Fibre Rag	310g/m² • 100% cotton rag • OBA & acid-free • museum-grade
	Baryta Photographique	310g/m² • acid-free • Baryta • museum-grade • pigment ink printers only
	Photo High Gloss Premium RC	315g/m² • resin-coated • alpha- cellulose • acid-free • ultra gloss
	PhotoGloss Premium RC	270g/m² • resin-coated • alpha- cellulose • acid-free • high gloss
	PhotoSatin Premium RC	270g/m² • resin-coated • alpha- cellulose • acid-free • satin
	Montval Aquarelle	310g/m² • OBA & acid-free • watercolor paper

Manufacturer	Paper name	Description
Canson	BFK Rives	310g/m² • 100% cotton rag • OBA & acid-free • museum-grade
	Mi-Teintes	170g/m² • OBA & acid-free • pastel paper
Marrut www.marrut.com	Pro Photo Gloss	265/m² • resin-coated • ultra white • gloss
	Pro Photo Satin/Oyster	265/m² • resin-coated • ultra white • semigloss
	Photobook Satin	290g/m² • resin-coated • white • semigloss • double sided
	Ultra Glossy Canvas Rolls	380g/m² • poly-cotton • white • gloss • canvas • only available in rolls for large-format printers
	Greetings Card Double Side Matte	220g/m² • white • matte • double-sided
	Standard Fine Art	310g/m² • 100% TCF pulp base • acid-free • creamy white • textured
	Smooth Fine Art	300g/m² • 100% cotton rag • pH neutral • acid-free • white • smooth
	Gloss Fine Art / Faux Baryta	280g/m² • 100% alpha cellulose • brilliant white • gloss • lightly textured
	Portfolio Fine Art	225g/m² • 100% cotton rag • pH neutral • acid-free • natural white • double sided
	Silk Fine Art	275g/m² • 100% cotton rag • acid-free • satin
	Pro Photo Matte	170g/m² • wood pulp • brilliant white • matte

HIGHLIGHTS *(Opposite)*
Any white highlights in an image will be the paper color when printed. For this reason, choose a paper with a "white" that is sympathetic to the image. This photo would not be suitable for a warm-toned paper, for example.

Pentax 67, 150mm lens, exposure not recorded, ISO 50 (Fuji Velvia)

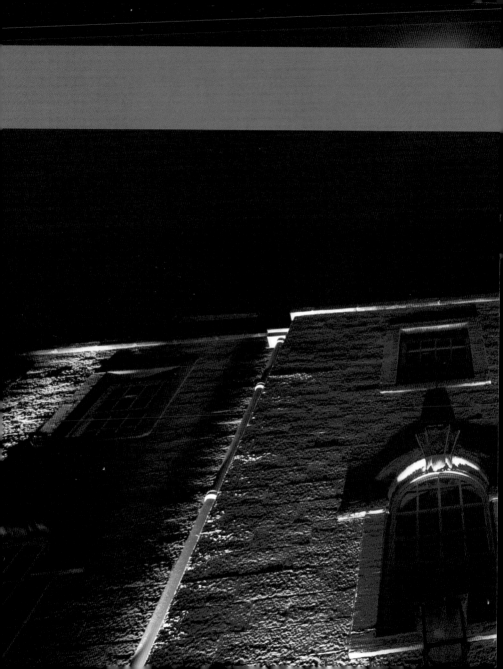

CHAPTER 3 COLOR AND CALIBRATION

Color and calibration

Understanding color, and how it is displayed on a monitor or output by a printer, will go a long way toward helping you take control of the look of your images.

Objectivity

Unfortunately human vision isn't perfect. We can't see color entirely objectively because our brain interprets color and there are many ways in which it can be fooled. This can get in the way of producing prints with accurate color. However, this problem can be partially overcome with experience and being aware of our perceptual limitations. Another way to overcome our shortcomings is to use less subjective methods of measuring color. This can be achieved by using devices known as colorimeters. These devices contribute greatly toward taking the guesswork out of achieving accurate color onscreen and in a print.

This chapter is all about color and how to take the first steps toward a reliable color-managed system. However, although this is quite a technical chapter, it is also worth stressing that color isn't just about numbers and computer files. The way we perceive color is subjective and this is partly the joy of it. Color has the power to lighten our mood or give us pause for thought. Enjoying color is part of what makes us human. We should always remember that, no matter how technically accurate we strive to be as photographers and printmakers.

COLOR
Color has a powerful effect on emotion. Which image on these two pages feels melancholy and why?

Digital color

Bits and bytes

A "bit" is the penny of the digital world. It is the smallest unit of information used by computers and digital devices such as cameras. A bit is analogous to a switch in that it can be set to either off or on. When a bit is set to off this is seen as 0 by the digital device. When the bit is on it is seen as a 1.

The next unit of information is the byte. A byte is eight bits. Computers use binary notation to count, and a byte (or eight bits) can be used to store numbers from 0 up to 255 (or from 00000000 to 11111111 in binary).

Imagine a world in which computer monitors were only able to display shades of gray. Each pixel on a monitor would either be black, white, or at a brightness somewhere in between. If you used a byte to define the brightness of a pixel you could have 256 different levels of brightness. A value of 0 would be black, 255 would be white and 127 would be exactly halfway between, creating a mid-gray pixel.

Of course monitors aren't just limited to shades of gray, but the principle is exactly the same for a color monitor. Three bytes are used to store the values required to display a full-color pixel. One byte is for red values, one for blue, and one for green. By combining red, green and blue (referred to as the RGB model) it is possible to create 16.7 million different possible color combinations (256 red values x 256 green values x 256 blue values).

Jargon Busting: Channels

If you were to separate the red, green, and blue components of a digital image and view them individually they would actually be grayscale. It is only when combined that a full-color image is created. When the color components are separated like this they are referred to as channels. So, an RGB digital image is composed of a red, a green, and a blue channel. Adobe Photoshop allows you to edit the channels combined (by default), or separately, by selecting the required channel on the Channels palette.

RGB and CMYK

In computing, red, green, and blue are primary colors, so called because mixing these three colors in varying proportions can make every possible color that can be displayed on a monitor or captured by a digital camera. RGB is an additive system, which means that at their maximum value of 255 red, green, and blue added together produces white.

Printers, on the other hand, use four primary colors: cyan, magenta, yellow, and black. This is known as the CMYK model. CMYK is a subtractive color system. It is only by the absence of the four colors that white is possible (where there is white in a print there is no ink). When combined, cyan, magenta, and yellow should theoretically produce black. However, inks aren't perfect so black ink is required to achieve solid-looking blacks.

Adobe Photoshop supports both RGB and CMYK and you can swap between the two on the **Mode** menu. However, unless you are preparing images for printing on commercial offset printers, you will never need to use CMYK mode. When using a domestic printer, the printer driver will convert the image automatically from RGB to CMYK for you.

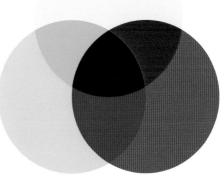

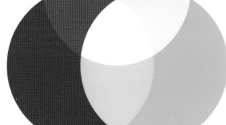

COLOR MODELS
RGB (left) and CMYK (above).

Color spaces

The average human eye is astonishing. It can distinguish between millions of different colors, even when there is only a subtle difference in brightness or saturation. The CIE 1931 standard is a mathematical model that defines the entire range of colors that the eye can perceive. The CIE 1931 standard is a "color space," but it is not the only one.

Designers of digital devices use the concept of color spaces to define the range of colors that a digital device is able to record, display, or print. This is a device-dependent color space and is specific to that device. The range of colors in a device's color space is known as its color gamut. A color that is outside this range is an out-of-gamut color and will not be displayed or printed correctly.

Color spaces vary in size. The CIE 1931 standard is an extremely large color space. For this reason it is used as a reference color space to which other color spaces can be compared. The color space of a typical monitor is far smaller than the CIE 1931 standard, and the color space of a printer is smaller still.

A color space can be represented three dimensionally. To imagine a color space visually, first picture a vertical pole. The base of the pole is black. As you run your eyes up the pole, black lightens to dark gray, mid-gray, and then at the top, to white.

COLOR SPACES
These are representations of two color spaces looking down from above. The color space on the left is a monitor color space. The one on the right is the color space of a paper profile. Note how the paper cannot reproduce colors to the same level of saturation as the monitor, particularly greens and blues.

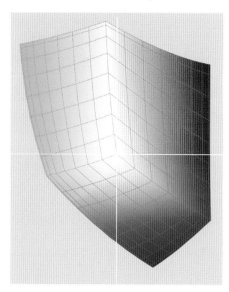

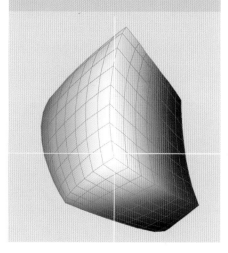

Next, spokes of color jut outward, at right angles to the pole, with a spoke for red, orange, yellow, and so on. The closer to the pole to spoke is, the less saturated the color. At the extreme end of the spoke, the color is at its most saturated. Finally, imagine that the pole and the spokes are covered with a tight skin. The skin shows how bright the color is relative to how close it is to the vertical pole. The shorter a color spoke in a device-dependent color space, the less the maximum saturation of this color when reproduced on that particular device.

Color management and ICC profiles

The fact that different digital devices record, display, or print different ranges of colors creates a problem. A particular color captured or displayed on one device will not necessarily look the same when reproduced on another. This is the problem that color management is designed to solve. Color management is a system that "translates" image data as it is passed between devices, so that colors remain reasonably consistent (with your PC acting as "translator"). To be able to work effectively, a color management system needs to know the exact color characteristics of the various devices in the chain. This is achieved by measuring the color output of each device and then recording this information in a file called an ICC profile.

Possibly the most important device that needs an ICC profile is the monitor used to view images. This is essentially the first link in the color management chain: if colors are inaccurate on the monitor, this will have ramifications further on. Monitors need to be regularly profiled as the colors they display will change gradually over time. Modern LCD monitors tend to be more stable in this regard than older CRT devices, but they're still not perfect.

Next, input devices need to be profiled. An input device is anything that is used to generate digital images, such as a scanner or digital camera. Digital cameras often give you the option of using one of two color spaces: Adobe RGB or sRGB. Compared to the CIE 1931 standard, the sRGB color space is approximately 65% smaller, whereas Adobe RGB is approximately 50%. Adobe RGB is therefore a bigger color space. If you're shooting images to be printed directly using PictBridge or a commercial photo lab, or to be uploaded to the Internet, you should use sRGB. However, if you intend to edit your images after shooting, use Adobe RGB so you are not constraining an image's color palette unnecessarily.

Finally, any output devices must be profiled. A printer, or rather the specific paper you print on, is an output device. Different papers have different color and ink absorption characteristics, and these must be defined with an ICC profile. It is generally possible to download canned ICC profiles for popular printer and paper combinations. However, for total accuracy it is better to create a custom profile for your particular printer, ink, and paper combination.

Note

Choosing the color space on a camera (such as the Canon EOS 5D MkIII, below) is more important when shooting JPEG. RAW files don't have a fixed color space—this is determined at the import stage.

Jargon Busting: Canned profile

A canned profile is one supplied by a printer or paper company for use with a particular printer and paper combination. Canned profiles are a good starting point toward a color-managed system. However, different batches of ink or paper can vary, so canned profiles may not be entirely accurate for your specific printer and paper.

Working spaces

Adobe RGB and sRGB are known as "working color spaces." A working color space is device-independent. They are used by image-editing software, such as Photoshop, to constrain the color values in an image to a predefined standard. As mentioned previously, Adobe RGB is a larger color space than sRGB. An even bigger color space is ProPhoto RGB. ProPhoto RGB is the preferred choice for many photographers for this reason alone. However, not everyone uses ProPhoto RGB, so if you need to pass on your images to other people you may need to convert the working space back to Adobe RGB or sRGB before you do so. To convert working spaces in Photoshop select **Edit > Convert to Profile** and select the required **Destination Space** from the **Profile** popup menu.

Notes

If you're saving an image to upload to the Internet, or to use in a multimedia presentation, or if you are having it printed at a photo lab, convert the working space to sRGB if that is not already selected.

ProPhoto RGB is only really suitable when working with 16-bit files.

Profiles, Windows, Macs, and Photoshop

Both Windows and Mac OS support ICC profiles and the concept of color management. Since the introduction of Windows Vista this has been achieved through the Windows Color System application, while Mac OS uses an application called ColorSync. Both applications take care of certain color management issues "behind the scenes," simplifying life considerably. Photoshop also supports ICC profiles. If an image is saved on another calibrated PC, the monitor ICC profile from that PC will be embedded into the data of the image. When you open the document on your PC, Photoshop compares the embedded profile with the profile on your PC. Photoshop then adjusts how the image is displayed so that you see it as it appeared on the original PC. When you are making a print, Photoshop uses ICC profiles to translate what you see on your monitor to how the image is reproduced in print.

Installing a profile

If you've downloaded a canned paper profile you will need to install it so that your operating system and Photoshop can find it.

Windows XP/Vista/7: Right-click on the profile and select **Install Profile** from the popup menu. Alternatively move the profile to **Windows > System32 > Spool > Drivers > Color.**

Mac OS X: Once the profile has downloaded, move it to **Library > ColorSync > Profiles**. If you're using OS X 10.7 (Lion) or higher, click on **Finder** and then click on the **Go** menu, holding down the Alt key as you do so. Click on **Library** to open the folder.

COLORSYNC
On a Mac you can use the ColorSync app to view ICC profiles as three-dimensional graphs showing the color gamut of the profile.

Photoshop Color Settings

One of the first tasks you should do once you've installed Photoshop is set your personal color management preferences. If you're using a variety of Creative Suite packages you can set color preferences in Adobe Bridge and these will then be applied globally. If you're just using Photoshop, open **Color Settings** by selecting **Edit > Color Settings**. On this page are my own personal Color Settings. These have been saved as **My Settings** (1) by clicking on **Save** (2). I use **Adobe RGB** (3) as my RGB working space. I occasionally need to save **CMYK** files (4) and this is the most relevant option for my needs. **Gray** and **Spot** can typically be left at their default settings. **More Options/Fewer Options** (5) reveals or hides options. When you import a document without an embedded profile, or with a different working space, Photoshop needs to know what you'd like to do with the file. I use **Preserve Embedded Profile** (6), though I do give myself the option of deciding whether I want to change my mind by checking all the **Ask When Opening** options below. I've left the **Conversion Options** (7) and **Advanced Controls** (8) at their defaults.

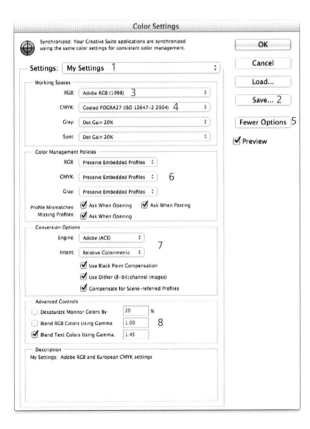

Working environment

Controlling the environment in which you edit and print images is an important part of the color management process too. Your surroundings have a large influence on how you perceive colors displayed on your monitor and in a print.

Displaying a busy, colorful image on your PC's desktop isn't a good idea, particularly if it can be seen as you edit your images. Although neutral gray backgrounds are a bit dull, they have the least effect on your color perception.

The same applies to the room that you work in. The wall behind your monitor should ideally be a neutral gray, or at the very least a relatively subdued color. Color reflecting on your monitor will also affect how you perceive images. Avoid wearing colorful clothing if possible and remove items from the area behind you if they can be seen on the monitor and prove distracting.

Consistent—and reasonably subdued—lighting is important. Daylight isn't consistent and changes color over the course of the day. If possible keep windows shaded or work in a room without windows. Artificial lighting brings its own problems. Tungsten lighting is very warm in color, whereas fluorescent lighting is more biased toward green. The most neutral type of lighting is that which conforms to the D50 standard (also known as Daylight Balanced or 5000° K lighting). If it's financially viable, it is worth investing in this type of light for your working environment.

COLORS
Colored backgrounds affect how we see adjacent colors. Which of the colored squares in the center of these two crosses is lighter? The answer is that they are exactly the same.

BACKGROUNDS *(right)*
Avoid busy desktop schemes such as this.

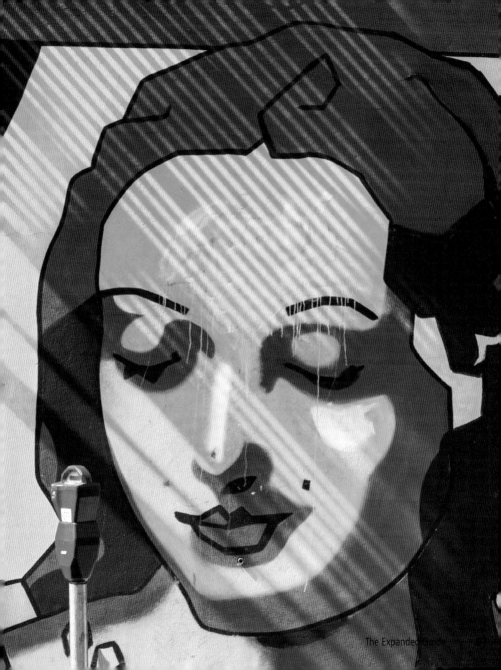

Profiling

Monitors

Monitors can be profiled in one of two ways. The first way is to use a software profiler, such as Adobe Gamma or ColorSync Calibrator. This involves adjusting the brightness and color of your monitor, based on decisions made as you view graphics shown by the software. Software profilers are far from ideal. They are better than nothing, but only just. A better solution is to use a hardware calibrator. This is a colorimeter (a device that measures color) that lies flat against the screen reading color patches displayed by the profiling software. By comparing the colors read from the monitor screen, and how those colors should look, the calibrator can produce an ICC profile for the monitor. Your PC can then use this profile to adjust the color output of the monitor so that it is more accurate.

Hardware calibrators are relatively inexpensive and often quickly pay for themselves by saving on wasted prints. The software that runs the calibrator will usually specify the ideal screen brightness and contrast, but for accurate results it is important to wait at least half an hour after first switching the monitor on, to allow it to warm up and reach its optimum brightness.

There are three ideal targets that are recommended when profiling a monitor. The first is achieving a white point of 6500°K. White point defines how cool or warm white is when displayed on a monitor.

Tip

Once the monitor profile has been created, rename it so that the filename includes the date. This makes it easier to keep track of when profiles were made.

SPYDER3PRO
Hardware monitor calibration setup screen.

The second target is a gamma of 2.2. Gamma affects the brightness of the mid-tones in an image. Too high a gamma value and the mid-tones will look too dark; too light and they'll look washed out. The final target is a luminance of 120–140 cd/m2. This will make the monitor appear quite dull, though it will help to avoid eyestrain. It's also another good reason to work under subdued lighting.

Printers

As mentioned previously, you need a profile for every paper type you regularly use. Unlike profiling a monitor there is no other way to profile a paper without using a hardware calibrator. The basic idea of creating a printer profile is to print out a test target on the paper you want to profile. The test target is typically a series of color patches, printed from an image file supplied by the manufacturer of the calibrator. Once you've allowed the print to dry (typically for 24 hours) you then manually read each color patch by placing it under the measuring sensor in the calibrator. This can take some time initially, though it does speed up with practice. Once each patch has been read and processed, the profile can be saved and used.

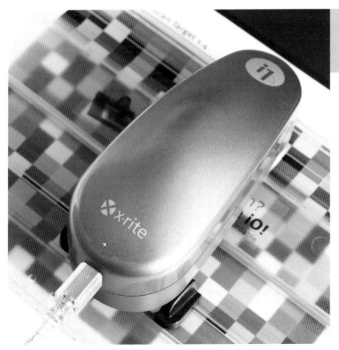

X-RITE i1
Hardware printer calibrator.

Manufacturer	Paper name	Description
PermaJet www.permajet.com	Gloss 271	271g/m² • resin coated • gloss
	Oyster 271	271g/m² • resin coated • semigloss
	Matte Plus 240	240g/m² • smooth matte • suited to monochrome printing
	Matte Proofing 160	160g/m² • matte • more suited to creating proofs than final prints
	Ultra Pearl 295	295g/m² • heavyweight • semigloss
	Digital Negative Transfer Film	Transparent film that can be used with pigment ink printers to create digital negatives
	Fibre Base Gloss 295	295g/m² • acid-free • gloss • slight texture
	FB Gloss Warm Tone 295	295g/m² • 100% cotton rag • acid-free • gloss • warm tone
	Fibre Base Matte (Delta) 285	285g/m² • bright white • matte paper • pigment ink printers only
	Fibre Base Royal 325	325g/m² • acid-free • bright white
	Photo Art Pearl 290	290g/m² heavyweight • semigloss
	FB Distinction 360	360g/m² • acid-free • very heavyweight • bright white • semigloss
	Alpha 310	310g/m² • 100% cotton rag • acid-free • warm-tone • semigloss

Manufacturer	Paper name	Description
PermaJet	Omega 310	310g/m² • 100% cotton rag • acid-free • neutral-white • calendered
	Portfolio 220	220g/m² • 100% cotton rag • acid-free
	Smooth Art Silk 300	300g/m² • 100% rag • acid-free • semigloss
	Portrait 300	300g/m² • 100% cotton rag • acid-free • calendered
	Portrait White 285	285g/m² acid-free calendered paper
	Portrait Velvet 310	310g/m² • 100% cotton rag • acid-free • calendered
	Artist 210	210g/m² • 50% cotton • canvas-like texture off-white
	Museum 310	310g/m² • heavyweight • loose weave texture
	Parchment 285	285g/m² • calendered white base and undulating texture
	Papyrus 300	300g/m² • 100% cotton rag • pH neutral • texture surface
	Double Sided Oyster 285	285g/m² • resin coated • semigloss
	Double Sided Portrait 300	00g/m² • 100% cotton rag • pH neutral • calendered • double-sided
	Double Sided Portfolio 230	230g/m² • lighter weight version of Portrait 300
	Double Sided Matt 250	250g/m² • smooth matte • particularly suited to monochrome printing

CHAPTER 4 PREPARATION

KN645

Preparation

When you've imported an image from your camera it's tempting to print it without further adjustment. However, a few minutes' preparation will save time and wasted ink and paper.

Objectivity

Enthusiasm is to be prized, but it does need to be reined in occasionally. Printing an image without first assessing it objectively can be expensive in wasted materials. There are four important factors that you should consider before printing an image. It is worth memorizing them and then thinking about each in turn before you even switch on your printer.

First, contrast. Is the contrast level correct in the image? There is no right or wrong answer to this as it is dependent on aesthetic considerations, as well as the type of paper you plan to use.

Next, color. An overall unwanted color cast is usually a reason for rejecting an image rather than printing it. However, it is also possible that specific colors in an image may not be suitable for printing. Oversaturation of a color is usually more of a problem than one that's less saturated, but both possibilities need to be considered before an image is printed.

How big should the image be printed? Obviously your printer will determine the maximum print size. Even so, you still need to consider how the image will fit onto the paper you use. And, if you plan to mount the print, you'll need to think about the size of the aperture in the mount.

Finally, does the image need sharpening? Again, a lot depends on aesthetic considerations as well as the type of paper you plan to use. Another factor is the size of the print and the potential viewing distance.

COLOR
Deep, saturated colors such as red can often prove problematic when printing.

CHECKLIST *(Opposite)*
Pilots run through a checklist before take-off to make sure that their plane is prepared. It's good practise to be as fastidious when preparing an image for printing.

Canon EOS 7D, 70mm lens, 1/100 sec. at f/2.8, ISO 400

FUEL
POUNDS
X 100

20

10

30

5

F

0

NO. I TANK

Digital files

To create a digital print you first need a digital image. This can be derived from a digital camera, scanned, or created from scratch using software such as Adobe Photoshop.

There are many steps that need to be taken to prepare a digital file for printing. The key to success at each step is not to restrict your options unnecessarily as you progress. The most obvious example of this is resolution. Cameras generally offer the choice of saving an image file at a number of sizes. If you were to use the smallest size offered then this would immediately restrict the dimensions of a print without compromising the quality of the print. For that reason I always shoot at the maximum resolution of the camera. Only when I am preparing an image for printing do I resize it to suit.

One of the first steps necessary when a digital image has been created is to save it. This is where a decision needs to be made. There are many different formats that can be used to save an image. The format you choose will have consequences later on if you plan to make further adjustments to your image. Some of these file format choices are described later in this chapter. First however, another quick dip into the world of bits and bytes.

FROM CAPTURE TO PRINT
Try to retain room for maneuver at every stage of preparing an image for printing. It's frustrating when a decision made early in the postproduction process limits your choices later on.

Bit-depth

A digital image that uses a byte for the red, green, and blue components that make up an individual pixel is referred to as an 8-bit image. Unfortunately 8-bit images aren't ideal if you plan to make major changes to aspects of an image such as color, contrast, or brightness. When one byte is used to represent a color value, an adjustment that generates a value that is a fraction (such as 197.6) means that the color value will need to be rounded up (or down). The more adjustments made, the more these rounding errors are exacerbated. This results in a visual effect known as "posterization," which is seen as odd color shifts or rough tonal changes in an image.

The solution is to use an image that has two bytes (or 16-bits) for each color value. In a 16-bit image there are 65,536 levels of color as opposed to 256. Unfortunately, most monitors and definitely all printers can't display this fine differentiation in color. In fact, the human eye would struggle to distinguish this range of colors. However, this extra color information is very useful "behind the scenes,"

with software such as Photoshop. A 16-bit image is far less prone to posterization than an 8-bit image. Ideally, if you plan to make a lot of alterations to an image, it is better to start with a 16-bit image than an 8-bit.

Notes

Sometimes you'll see the terms 24-bit and 48-bit used to describe an image. A 24-bit file is actually an 8-bit file, but that specifies the fact that three bytes are used for the red, green, and blue components of the image (8-bits x 8-bits x 8-bits = 24 bits). A 48-bit file is similar, but describes a 16-bit image.

A 16-bit file will be typically twice the file size of an equivalent 8-bit file. This means that 16-bit files take up far more storage space. For this reason most photographers edit an image in 16-bit and, when editing is complete, convert the file to 8-bit before saving.

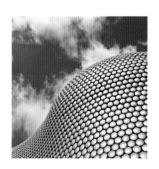

POSTERIZED #1
This 8-bit image has been overprocessed. The posterized colors in the clouds are testament to this.

JPEG

JPEG is an image file format and is short for the Joint Photographic Experts Group, referring to the software development team that originally created the format.

All digital cameras can create JPEG images. This is for two main reasons. The JPEG format is supported by thousands of different applications, from word processors to the Internet. Indeed it would be very unusual to find an image-friendly application that didn't support JPEG.

The second reason is more subtle. The image data in a JPEG is compressed to reduce the file size—in terms of space required to store the file, rather than image resolution. This is useful when memory card or hard drive space is at a premium. JPEG compression is achieved by simplifying fine detail in the image. At low levels of compression this loss is often difficult to spot, but it is very obvious when a high level of compression is used. The greater the loss of detail, the smaller the print size would need to be to avoid this loss being noticeable.

Digital cameras usually allow you to choose the "style" of your images. This can be as simple as increasing or decreasing contrast to something as esoteric as applying a fisheye effect. The chosen style is "baked" into the JPEG at the moment of capture and it is difficult, if not impossible, to remove this later. Again, this can potentially limit your printing options. If in doubt, set the compression level to the lowest possible on your camera and use a neutral "style"—one that avoids high contrast, sharpening, and extreme image effects.

Note

JPEG is an 8-bit file format. Images in 16-bit mode must be converted to 8-bit before they can be saved as a JPEG. JPEG also does not support Photoshop Layers.

JPEG COMPRESSION
Detail of a heavily compressed JPEG file. At 100% magnification the blocky artifacts are very visible.

RAW files

RAW files are created by digital cameras (though not all cameras support RAW) and some scanning applications. RAW is digital image data without processing applied—essentially it's the data captured by camera or scanner at the moment of exposure. Unlike JPEG there is no RAW standard and different camera manufacturers use different methods to order the data in a RAW file. This means that only software compatible with a particular "flavor" of RAW can be used to open the RAW file.

This makes an image saved in RAW less immediately useful than a JPEG. However, a RAW file is far more amenable to adjustment without loss of quality than a JPEG. This is because RAW files can be opened in 16-bit mode. Also, because a RAW file hasn't been processed there is more scope for personal interpretation of the image. The decision about whether an image should be black and white or high in contrast can be decided in postproduction, not at the moment of exposure. Perhaps more importantly, RAW files are unsharpened. This means that the choice of

Notes

The image data in a RAW file is never altered. If you make adjustments to a RAW file, the "recipe" for these adjustments is saved either in a database (when using software such as Adobe Lightroom) or as a separate .XMP file when using Adobe Camera RAW.

RAW files must be exported to a different file format, such as JPEG or TIFF, if you want to use the image with software that is not RAW compatible.

how much or how little sharpening needed is entirely up to you. This is an important step when printing an image. There is more information about sharpening later in this chapter.

RAW files don't make life easier in the way that JPEGs do. They require a greater level of commitment in time and effort. However, as the basis for preparing an image for printing they can't be beaten.

ADOBE LIGHTROOM
Image-editing software compatible with most RAW formats.

PSD and TIFF

PSD is short for Photoshop Document and was developed by Adobe for use with Photoshop. Because of this, PSD files support many features of Photoshop, so images can be saved with layers and masks, and appended with ICC profiles and so on. The PSD format also supports both 8- and 16-bit image modes. This means that it is possible to retain maximum image quality as you process an image. The only drawback to saving a 16-bit PSD file, particularly one with layers, is that the file size may be large (PSD files are compressed, using a method that doesn't lose detail like JPEG, but the compression method has its limitations). There are a number of applications that support PSD but these are fewer than those that support JPEG.

An alternative to the PSD format is TIFF, or the Tagged Image File Format. TIFF shares many of the features of PSD, including support for layers and 8- and 16-bit image modes. It is more widely supported than PSD, though again not to the same extent as JPEG. Many professional printing applications require the use of TIFF files in preference to PSD. TIFF files can be compressed using non-destructive methods such as Zip. Images can also be compressed using JPEG compression, though as with true JPEG this will mean the loss of some detail in the images.

KITCHEN SINK
PSD and TIFF are vital if you want to save your images with Photoshop functions such as layers and alpha channels.

Workflow

The key to creating successful prints is establishing a consistent workflow. A workflow is an ordered series of processes or tasks that must be worked through to a specified end result. In the case of printing this would mean taking a digital image from its standard form to one that is suitable for printing. There are many tasks that can only be done at very specific points in a workflow.

The workflow below is the one I apply when preparing an image for print. It's not vitally important that you follow all the details, but it should give you a good framework for creating your own workflow. The workflow starts at the point where I've opened a 16-bit RAW image in Photoshop, having already imported it from my camera.

One important aspect of my workflow is that I never adjust the original image: I always create a duplicate and adjust that. This means that I will never erase my original image by accidentally replacing it with the print-ready image.

Task	Sub-Tasks
Editing	Rotate, straighten, or crop if necessary
	Correct for lens distortion and chromatic aberration
	Clean up dust spots or blemishes
	Apply noise reduction
	Adjust white balance
	Alter image contrast, color saturation, and brightness as necessary
	Convert to 8-bit and save as JPEG
	Update digital asset management database
Printing	Open and duplicate image. Close original
	Resize duplicate to the required print dimensions
	Sharpen duplicate as required
	Print
	Close duplicate without saving

Histograms

A histogram is a graph showing the distribution of tones in a digital image. Most digital cameras can show histograms either during Live View or after capture when the image is displayed in playback. Histograms are also used by image-editing software such as Adobe Photoshop. In this instance they are extremely useful for letting you see the effects of adjustments made to an image.

A histogram is read horizontally from left to right, with black (with an RGB value of 0, 0, 0) on the extreme left edge across to white (with an RGB value of 256, 256, 256) on the extreme right edge. The vertical lines in a histogram show the number of pixels in an image that correspond to a particular tone.

There are two types of histogram that are commonly used: luminance and RGB. A luminance histogram assumes that a pixel has a brightness that corresponds to a particular grayscale value. Where that pixel is recorded in the histogram depends on the median values of the RGB components of the pixel. As an example, a pixel with an RGB value of 90, 158, 70 has the same brightness as mid-gray. So, this pixel would join others of the same brightness halfway across the histogram.

RGB histograms show the distribution of pixels depending on their RGB values. This is shown as either three separate histograms, one for red, one for green, and one for blue, or by combining the three into one histogram, using the relevant colors to distinguish between the red, green, and blue components.

Tip

*To view the histogram for an image in Adobe Photoshop select **Window > Histogram**.*

POSTERIZED #2
This image has been overproccessed deliberately to produce the histogram on the opposite page.

If a histogram is squashed against either the left or right edge, it is referred to as being "clipped." Pixels on the left edge of the histogram are black (0, 0, 0 RGB). When printed out, these pixels will be solid black, or at least as black as is possible with the printer and paper combination you are using. Pixels on the right edge are pure white (255, 255, 255 RGB). These pixels will not be printed—printers don't have white ink—so the color of the paper used will show through in any area of an image that is pure white.

There is no "correct" shape for a histogram. A histogram only ever shows you the distribution of tones in an image. It is up to you to decide whether the tonal distribution is correct. A histogram that is skewed to the left could be an indication of underexposure, but equally this is the type of histogram you'd expect if you had created a dark, low-key image for aesthetic reasons.

However, a histogram should be relatively smooth. If you make a number of tonal adjustments to an 8-bit image in postproduction the histogram may look jagged or comb-like. This is an indication that you have exceeded the sensible limit of adjustments you can make to the image. An image with this type of histogram will no longer have smooth tonal transitions. When printed you will see abrupt or unusual changes from one color to another. This is the effect known as posterization, and is one of the reasons why it is better to start with a 16-bit image, rather than an 8-bit image.

POSTERIZED #2
This is the histogram of the posterized image on the opposite page. The fragmented graph is an immediate indication that the file has been overprocessed.

Image adjustments

There are many reasons why an image straight from a digital camera may not be ready for final printing—particularly if the image is derived from a RAW file. The following pages cover some of the very basic adjustments you can make to an image to prepare it for printing.

Software

Adobe Photoshop is the software package most people associate with image editing. At the time of writing the latest version is CS6, released in the spring of 2012. The image adjustments, and the way to use them as described in this chapter, are all Photoshop specific. However, many other image-editing packages—such as GIMP or even Adobe's Lightroom package—closely follow the Photoshop model. Therefore, much of what will be described on the following pages will still be relevant. This also applies to Photoshop Elements, a "domestic" version

of Photoshop with many of the more esoteric tools removed. Rather than cover very basic tasks—such as loading and saving a file—some knowledge of Photoshop is assumed. There is also not enough space here to cover every aspect of Photoshop. That is a subject for an entire book! However, the tools described are the essential ones for preparing an image for printing.

Jargon Busting: GIMP

GIMP, or the GNU Image Manipulation Program, is a free, opensource photo editor available for both Windows and Mac from www.gimp.org. Many of GIMP's functions —such as the ability to use layers—are comparable with Photoshop. However, using and installing GIMP does require some technical knowledge.

ADOBE PHOTOSHOP CS6
Running on Mac OS X.

Global vs. Local

There are two broad types of adjustment you can make to an image: global and local. A global adjustment is made to the entire image, whereas a local adjustment is made to a specific area only. An example of a global adjustment tool in Photoshop is Brightness/Contrast (described on the following page). Any changes you make when using the tool are applied across the entire image. The Dodge/Burn/Sponge tools are applied locally, allowing you to lighten, darken, or alter the vividness of colors respectively, by brushing the changes to the image. These tools are described *on page 104*. However, the effects of global tools such as Brightness/Contrast can also be applied locally through the use of adjustment layers and layer masks. The concept behind these is described *on page 100*).

My approach to image adjustments is to start globally, to adjust an image until it is broadly satisfactory. Then, I make the local adjustments for specific areas that may need more work. One problem is knowing when to stop, as it is possible to overwork an image to its detriment. A good way of working is to prepare an image to a certain point and then leave it for a period of time—five minutes or so. Then, when you return to the image, it is often easier to assess whether it is ready or whether more polishing is required.

Tip

To undo an action in Photoshop press Ctrl+Z (Windows), or Cmd+Z (Mac)

LOCAL
This image has had an exaggerated local adjustment made for the purposes of illustration. However, I could have been subtler and applied a local adjustment that sharpened the same area to bring out detail in the grasses, for example.

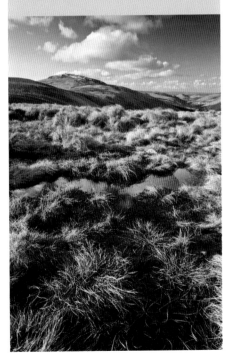

The Photoshop interface

If you're a do-it-yourself buff you'll probably have a toolbox and a workbench. If you're efficient, each tool will have a specific place so that you can easily reach for it. When you're done, you replace the tool back in its proper home, ready for next time. Photoshop has a wide number of tools to help you adjust images, with the added benefit that you don't need to replace them afterward.

The Photoshop interface has a number of different components. You can configure the interface in a number of different ways, but it is sensible to keep it as simple as possible to start with. The Tool panel (1) contains many of the tools that allow you to make local adjustments. Many of these tools are used like a brush, so that adjustments are painted directly to the image. The way a tool operates can be altered. The options for altering tools are found on the Control panel (2). Photoshop can display a number of panels (3), which can either show information about an image or contain more complex tools to modify an image. The panels to be displayed can be selected from the Window menu. Panels can also be hidden on a sidebar (4), giving more screen area to the image (5), but still keeping them efficiently handy. Finally, some Photoshop tools are displayed as dialog boxes (6) that only appear when selected from a specific menu.

Brightness/Contrast

By far the simplest tonal adjustments you can make to an image are to adjust either the brightness or the contrast. The Brightness/Contrast tool is easy to use and has been part of Photoshop's toolset since the very first version. The one black mark against the tool is that it is very crude and doesn't allow you the fine control of a tool like Curves. Brightness/Contrast is applied globally, or can be applied locally when used as an adjustment layer and with a layer mask.

Adjusting Brightness/Contrast

1) Open an image and then select **Image > Adjustments > Brightness/Contrast**. Leave **Use Legacy** (1) unchecked.

2) Pull the **Brightness** (2) slider to the left to darken the image—expanding the shadow areas. Or, move the slider to the right to lighten it—expanding the highlight areas.

3) Pull the **Contrast** (3) slider to the left to decrease the contrast in the image—making the image appear flatter and grayer by pulling the darkest and lightest tones in the image closer together. Alternatively, move the slider to the right to increase contrast—making the image look punchier by pushing the darkest and lightest tones further apart.

4) Click **OK** to adjust your photograph or **Cancel** to exit Brightness/Contrast without making the adjustment.

Notes

*Checking **Use Legacy** offers a more extreme range of brightness and contrast adjustment. However, with this option checked it is possible to burn out the highlights and lose shadow detail, something that is not possible when the option is unchecked.*

*Uncheck and check **Preview** to see a "before" and "after" of the adjustments you've made before you click on **OK**. This applies to a lot of the other tools covered in this chapter.*

*Clicking on **Auto** lets Photoshop determine the optimum brightness and contrast automatically. Sometimes this works and sometimes it doesn't. For fine control of your images, it is not recommended.*

You can add numerical values into the relevant boxes rather than using the sliders.

Levels

The Levels tool is a more precise—if slightly less intuitive—way to adjust the tonal range of an image than Brightness/Contrast.

When you open an image and select Levels —**Image > Adjustments > Levels**—you'll see a histogram in the center of the dialog box. This shows the tonal range of the image before adjustment. Below the histogram are three triangles that can be moved left or right. The solid black triangle (1) is used to control the black point in the image. Moving the black point to the right will increase the number of pixels that are black (or 0, 0, 0) in the image. The white triangle (2) controls the white point. Moving the white point to the left will increase

the number of pixels that are white (or 255, 255, 255) in the image. The gray triangle (3) controls the mid-tones in the image. Moving the mid-tone triangle to the left compresses the number of dark tones in the image, making it lighter; moving it to the right compresses the number of light tones, making the image darker.

The black (4), mid-tone (5), and white (6) points can also be set manually by clicking on the relevant eyedropper tool below the **Options** button. As an example, if you select the black eyedropper you can choose the black point in an image. If you click in the image, the color value of the pixel below the eyedropper will be set to 0, 0, 0. Any pixels darker than the selected pixel value will also be set to black. The **Output Levels** (7) change the RGB values of the darkest and lightest tones in an image. Move the black output level right and the darkest tones lighten, move the white output level left and the lightest tones darken.

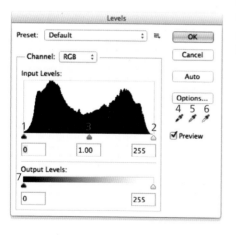

Case Study: adding contrast

Levels can be used to quickly add contrast to an image. The inset image was converted from a RAW file, without contrast adjusted. Opening Levels showed me that the tonal range was concentrated around the mid-tones (1). By pulling the black and white points closer together (2) I was able to spread the tonal range further apart, adding much needed contrast to the image.

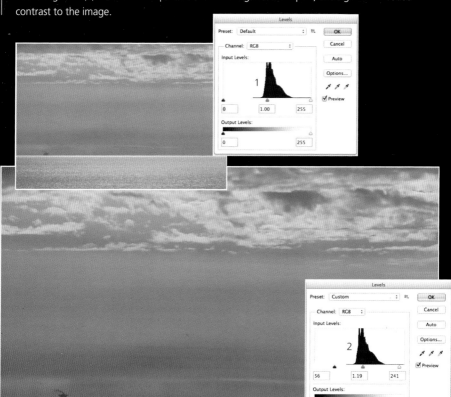

Curves

Curves is probably the most useful of Photoshop's image adjustment tools, but also the least intuitive. When you first select Curves you will see a histogram displayed in a box in the middle of the Curves panel. Running diagonally, from the top right corner of the box to the bottom left is a straight line, with no curve in sight. The straight line is the Input line and it is this line that can be pulled and stretched into a curve. The Input line controls how tones in an image are adjusted.

Below the histogram is the Input values strip, which represents the original tones in the image, from black on the extreme left to white on the extreme right. To the left of the histogram is the Output value strip, representing how the Input values will alter once the shape of the Input line is changed.

When the Input line is straight, the input and output values match, which means that no tonal adjustments have been made to the image (1). By clicking on the Input line, a control point is added. If the control point is then moved upward, the Input value stays the same but the Output value is increased. This means that the Input tones directly below the control point (2) are altered in the image so that they match the Output tones directly to the left (3).

Pull the point downward and the output value decreases and the tones are darkened. With the tone curve set to *Point* you can add more points to make an increasingly complex curve, affecting different parts of the tonal range in different ways.

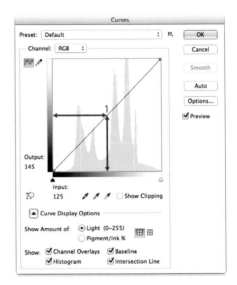

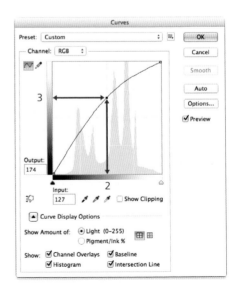

As with Levels, you can also affect the tonal range of the image by moving the black point and white point triangle below the Input values strip. When you move the triangles, the end points of the curve above move in the same direction. You can also set the black, mid-tone, and white points of the curve by clicking on the relevant color picker below the Input values strip. A neat feature of Curves is that you can draw a curve freehand by clicking on the pencil icon below the **Channel** popup menu.

Curves can also be used to adjust the color balance of an image. By default the **Channel** popup menu is set to RGB. However, you can set **Channel** to **Red**, **Green**, or **Blue**. With one of these options selected the curve only affects the relevant color channel. As an example, if you select Red, moving the curve upward will lighten the red, making the image redder. Moving the curve downward will have the opposite effect, darkening the red channel and making the image blue-green.

Case Study: the S-curve

A simple, but useful curve shape is the s-curve, created by adding two control points to the curve—roughly one third and two thirds along the curve—and then moving them vertically in opposite directions. By creating an s-curve, image contrast can be adjusted. Pulling the higher control point upward and the lower point downward causes contrast to be added to an image. Conversely, pulling the higher control point downward and the lower control point upward reduces contrast.

This image, converted from an unprocessed RAW file, lacks contrast. This is made more apparent by looking at the histogram. There are few dark or light tones and there is a large peak in the middle indicating a predominance of mid-tones. The image is flat and lifeless and would produce a similarly uninspiring print.

The first improvement that can be made is to increase the contrast. This could have been achieved through the use of Brightness/Contrast. However, I felt that the use of an s-curve would give me greater control. What I didn't want to do was increase contrast to unnatural levels. The image was shot in soft light so there are no deep shadows or bright highlights. The s-curve I created was therefore relatively shallow—but was enough to add some bite to the image. There are still other improvements that need to be made—the color for example—but a start has been made to prepare the image for printing.

Color Balance

A common problem in photography is when an image has an unwanted color cast. If you're using RAW this can be cured at the import stage by altering White Balance. However, if you're shooting JPEG you won't have that option. Fortunately Photoshop's **Color Balance** will come to the rescue (**Image > Adjustments > Color Balance**). As the name suggests it allows you to balance the color in an image. There are three sliders on the **Color Balance** panel: one to adjust the image between **Cyan** and **Red**, one to adjust the image between **Magenta** and **Green**, and one to adjust between **Yellow** and **Blue**. As an example of how to use **Color Balance**, if you shot an image under fluorescent lighting you may find that it had an overall green cast. If this were the case

you'd add more **Magenta** to the image to counteract the green.

You can specify what part of the tonal range is affected by **Color Balance** by selecting **Shadows**, **Midtones**, or **Highlights**. When **Preserve Luminosity** is selected, the colors that are adjusted are lightened or darkened so that they still have the same apparent brightness.

Tip

You don't need to be technically correct when adjusting color: portrait images often benefit from being slightly "warmer."

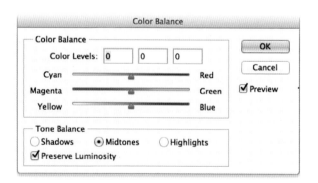

COOL *(Opposite)*
Images of snow scenes can often be excessively blue. For this image I used Color Balance to 'warm' the image up.

Canon EOS 1Ds MK II, 35mm lens, 1/20 sec. at f/16, ISO 100

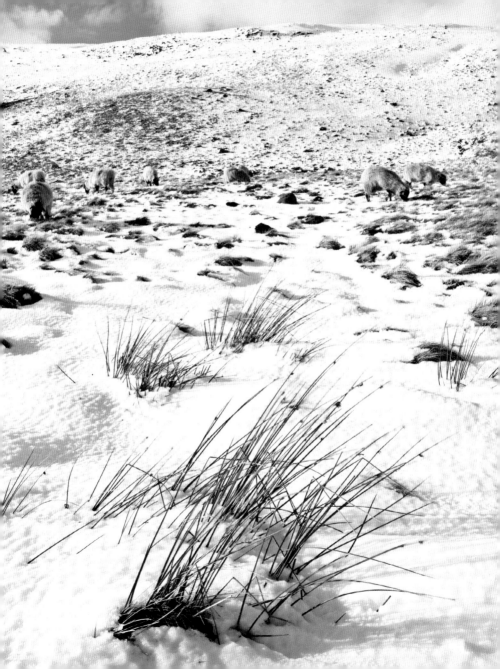

Layers

Although the adjustments mentioned in the past few pages are invaluable in preparing an image for print, they will permanently alter your picture. The more you adjust an image, the more difficult it will be to restore it to its original state. This is particularly true if you save and then reopen the image.

One way round this problem is to use Photoshop's Layer system. A layer has the same effect as placing a sheet of glass over your image: you can draw or paint on the "glass" without altering the image below. Parts of an image can be copied to a layer, allowing you to make local adjustments. You can also add a stencil to a layer, known as a mask, which allows you to specify very precisely which parts of a layer are shown and which are hidden.

Multiple layers can be added to an image and are shown stacked on the **Layers** panel. The order of the layers in the stack runs down from top to bottom, with the highest layer in the stack being above all the other layers. The very lowest layer, at the bottom of the stack, is usually called **Background**. The order of the layers in the stack can be changed by clicking on a layer and dragging it up and down the stack.

Individual layers can be temporarily turned on or off by clicking on the eye icon on the left of the Layer strip. To permanently remove a layer, drag it down to the trash can at the bottom right of the panel.

LAYERS
This huge apple wasn't really towering over the landscape when the image was made. Instead it's been cut from another image and pasted into a layer above the landscape image.

Once you've created a layer, you don't necessarily need to display it at full "strength." You can alter the transparency of a layer by altering the **Opacity** value. When **Opacity** is set to 100% the layer is fully visible and at 0% it is completely transparent. You can also alter the way a layer interacts with those below it in the layer stack, by changing the **Blend** mode

using the popup menu. The default is **Normal**, but there are options such as **Multiply** and **Screen** that radically alter how the pixels in the layer interact and are mixed with pixels in the layers below.

As previously mentioned, not all file formats support layers. JPEG is not compatible with images with layers, and the layers must be "flattened" before you save in this format. Photoshop's PSD format and TIFF are both compatible. Flattening layers merges them all together so that only the Background layer remains. You can also select multiple layers and merge those together. To select multiple layers click on the layers you want to select while holding down shift. Options such as flattening or merging layers are found on the layer options popup menu or by navigating to the **Layers** menu at the top of the screen.

Tip

*The Layers panel should be visible when you first install Photoshop. If it is not, you can display it by selecting **Windows > Layers**.*

COMPLEX
It doesn't take long for a layer stack to look cluttered. Working logically, renaming layers and adding layers into groups will help you keep track of the stack. To rename a layer double-click on the original name shown in the stack.

Layers Panel Guide (CS6)

1 Layer filter popup menu. Once a layer stack is a reasonable size it can sometimes be difficult to find a particular layer. Layer filtering allows you to specify which layers are displayed depending on certain criteria.

2 Filter for pixels layers.

3 Filter for adjustment layers.

4 Filter for type layers.

5 Filter for shape layers.

6 Filter for smart objects.

7 Turn layer filtering on/off.

8 Layer options popup menu.

9 Blend mode popup menu. By default the Blend mode is **Normal.**

10 Layer opacity. Lowering the opacity of a layer decreases the visibility of pixels in the layer.

11 Lock transparency. Locks areas of transparency in a layer so that they can't be edited.

12 Lock image pixels. Locks the pixels in the layer so that they can't be edited.

13 Lock position. Locks the pixels in the layer so that they can't be moved.

14 Lock all. Locks all aspects of a layer so that it can't be edited further.

15 Fill. Adjusts the transparency of the image pixels in a layer but not pixels that have been added by selecting a layer style.

16 View layer icon. Clicking on the icon turns a layer off temporarily. Click again to turn the layer back on.

17 Adjustment layer.

18 Inactive layer.

19 Layer mask.

20 Background. By default the lowest layer in the stack.

21 Link layers. By selecting multiple layers you can link them together for moving or merging together without affecting other layers in the image.

22 Add layer style. Adds an effect to the currently highlighted layer, such as a drop shadow.

23 Add layer mask. Adds a mask to the currently highlighted layer.

24 Create new fill or adjustment layer. *See next page.*

25 Create a new group. You can collect layers together as a group. This can be used to tidy up the layers panel and stop it looking too cluttered. Like individual layers, groups can be switched off temporarily, this will also switch off all the layers within that group.

26 New layer. Click on the icon to add a new or drag an already existing layer to the icon to make a copy of that layer.

27 Delete layer. Drag a layer down to the trashcan to permanently delete it.

Adjustment Layers

Adjusting an image using the tools previously described is an all or nothing affair. Adjust the contrast, make a few other changes, and then… you decide that you didn't want to alter the contrast after all. You could go back through the image history and undo all the changes you've made, but this isn't ideal. What would be useful is to apply a tonal change and then be able to undo it or alter it at any point after that. Fortunately, you can do just that with adjustment layers.

An adjustment layer is added to the layer stack just like a normal layer. However, it contains no pixel information. It is an instruction to affect all the layers below with a particular adjustment. Like a standard layer, an adjustment layer can be temporarily turned off, the opacity altered, or the adjustment layer deleted entirely.

Let's say you want to apply a Levels adjustment layer to your image: click on the *Create new fill or adjustment layer* button on the layers palette and then select **Levels** from the popup menu. The standard Levels dialog box will then open (either as a separate dialog box in earlier versions of Photoshop, or as a Properties panel in later versions). You would then make the necessary adjustments (older versions of Photoshop require you to click OK at this point to create the adjustment layer, newer versions create the adjustment layer automatically).

ADJUSTMENT LAYER
(Top) Adjustment layer added but temporarily turned off.

(Bottom) Adjustment layer added and turned on.

Layer Masks

To lessen the effect of a layer you can lower its opacity, which will make it more transparent. However, this affects the entire layer. If you want to be more selective a better option is to add a Layer Mask to the layer.

A layer mask is essentially a stencil that determines which part of a layer is see-through, and to what degree, and which part is opaque. A layer mask has exactly the same pixel resolution as the associated layer and when first added to a layer is entirely white. Anywhere there is a white pixel in a layer mask means that the corresponding pixel in the associated layer is opaque—that means that pixels in the layers below cannot be seen. However, add a black pixel to the layer mask and the corresponding pixel in the associated layer is made entirely transparent—allowing pixels in the layers below to be seen. To create pixels that are semitransparent you add gray pixels to the layer mask. The darker the gray, the greater the transparency; the lighter the gray the lower the transparency. If you don't like the results you can keep altering the pixels in the layer mask or delete it entirely and start again—all without affecting the layer you're working on.

Adding a layer mask

1) Select an image with multiple opaque layers and then click on the top layer in the stack. Click on the **Add layer mask** button at the bottom of the layer palette. A white-filled box should now be visible to the left of the layer image thumbnail. This white-filled box is the layer mask.

2) Select the **Brush** from the Tool panel (you can use any of Photoshop's drawing tools but the Brush tool is a good starting point). Increase the **Size** so that you can easily see the effect as you paint with the tool and set the **Opacity** of the Brush to 100%.

3) Set the **Foreground color** to black and begin to paint anywhere in the image. As you do so you should see the layer beneath begin to show through. If you look at the layer palette you should also see that the white box now has a black shape within it, corresponding to the shape you drew within the image. Congratulations! You've just created a layer mask.

Notes

To delete a layer mask but not the associated layer, click and drag the layer mask box down to the trashcan at the bottom of the layer palette.

The layer mask is always to the right of the layer thumbnail. Click on it to edit it.

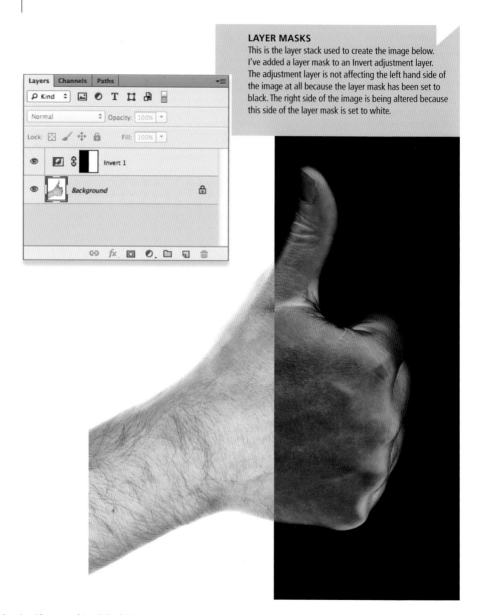

LAYER MASKS

This is the layer stack used to create the image below. I've added a layer mask to an Invert adjustment layer. The adjustment layer is not affecting the left hand side of the image at all because the layer mask has been set to black. The right side of the image is being altered because this side of the layer mask is set to white.

Case Study: adjustment Layer with a layer mask

I liked the exposure of the window in this image (left) but felt that the surrounding area would be less distracting if it were darker.

The easiest way to achieve this was to use an adjustment layer with a layer mask. I could have used Curves or Brightness/Contrast, but in this instance I used Exposure. I initially adjusted the exposure so that the entire image was made darker. Then, setting the foreground color to black, I painted in an area that roughly corresponded to the arch of the window. This was a little too rough, so I then used Gaussian Blur (**Filter > Blur > Gaussian Blur**) at 50 pixels to soften the outline of the mask.

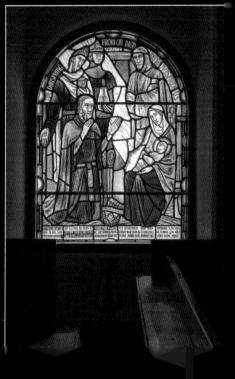

Dodge, Burn, and Sponge

Many of the tools in Photoshop are directly analogous to tools found in a traditional darkroom. The tools that have the closest link are the **Dodge** and **Burn** tools. The **Dodge** and **Burn** tools are based on the technique of holding back light to lighten a specific area of a print (known as dodging) or increasing the exposure to darken a specific area (known as burning).

Both tools are essentially brushes than can be painted onto an image. This means than you can specify the size of the brush, how hard or soft it is, and its opacity on the control panel. The **Dodge** and **Burn** tools are both found on the Tool panel (they share the space on the panel with the Sponge tool, so only one will be shown at a time). Once you've selected one of the tools, you can set the size (in pixels) and hardness by using the popup menus on the Control panel. A shortcut to altering the size of the tool is to press **[** to shrink it and **]** to expand it.

You can control which tones the tools affect by choosing an option from the **Range** popup menu. Select **Shadows** and the selected tool will affect the darker tones in your image, **Midtones** the middle tones, and **Highlights** the brightest tones. **Exposure** alters how quickly the dodge and burn tool affects the tones you are altering. A higher value will have a stronger effect.

The **Sponge** tool doesn't affect the brightness of tones in the image. Instead it alters the saturation of colors. Choose **Desaturate** from the Control panel and colors will become less vivid, whereas **Saturate** increases the vividness of colors.

DODGE (LEFT), BURN (CENTER), SPONGE (RIGHT)

Resolution

The term resolution, when applied to photography, has a number of different meanings. The most commonly understood meaning refers to the pixel resolution of a digital image, which is the number of pixels used to create the image. This is usually shown by two figures, the first being the width in pixels, the second being the height. A 1024 x 768 pixel image is therefore one that measures 1024 pixels across by 768 down.

To create a print you need to translate pixels into ink. The generally acknowledged standard for printing photo-quality images is 300 pixels per inch (shortened to ppi), which means that 300 pixels in an image will equate to one inch in a print. If a digital image is 3000 pixels across, then a print created at 300ppi will be exactly 10 inches wide (3000 pixels divided by 300 equals 10 inches).

To make a bigger print than this at 300ppi, an image would need to have a higher pixel resolution. If you wanted to create a 20-inch print at 300ppi, you'd need to start with an image that was 6000 pixels across. There aren't many digital cameras that can shoot at a resolution this high, so a solution straight out of the camera isn't usually possible. One answer is to increase the size of the image by a process

Notes

Increasing the size of digital images created by scanning film isn't recommended.

If you prefer metric, the equivalent to 300ppi is 118.11ppc (pixels per centimeter).

Photoshop refers to pixel resolution as Pixel Dimensions.

PHOTOSHOP:
IMAGE SIZE
Note Document Size and Resolution.

known as interpolation. When an image is increased in size, new pixels need to be added. Interpolation is the method used by software to make an educated guess as to the color values of these new pixels. Images from a digital camera are surprisingly robust and can be increased in size to a surprising degree without quality dropping too far.

However, you don't always need to use 300ppi when making a print. The ppi value is arbitrary and only affects the final print size of an image—not the number of pixels in the image. You could, for example set a 3000-pixel image to a ppi value of 150. This will create a print 20in. across—achieved not by increasing the number of pixels in the image, but by spreading the existing pixels across a greater area in the print. In doing this the print quality will drop. However, this is compensated for by the fact that a larger print is generally viewed from a greater distance than a smaller print.

The lower the ppi value you use, the larger an image can be printed. If you were to use a value of 1ppi, a 3000-pixel image would be 3000in. (or 250ft) across. Although close-up the quality would be horrendous, from a reasonable viewing distance the image would look perfectly acceptable. Don't believe me? Next time you pass a large advertising hoarding walk up to within a few feet of it and look at the print quality. It won't be photo quality by any means, but this is not noticeable because no one looks at advertising hoardings from such a short viewing distance.

RESOLUTION
The small image on this page has been printed at 300ppi. The image on the opposite page has been printed at 50ppi (using the same number of pixels as the smaller image) lowering the quality. However, prop the book open at this page and walk back from it. At a certain distance you will not notice the reduced quality.

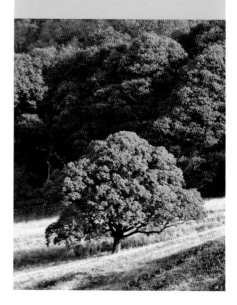

Changing image size in Photoshop

1) Open the image you wish to resize.

2) Select **Image > Image Size**.

3) With **Constrain Proportions** and **Resample Image** checked, click in either the **Width** or **Height** box below **Document Size**. Alter the value to the required size for your print. Note that as you change the size value the Pixel Dimensions alter also. If you make the image smaller the pixel resolution will decrease (pixels are removed) or, if you make the image larger, the pixel resolution increases (pixels are added).

4) Click **OK** to set the image size.

Changing ppi/ppc in Photoshop

1) Open the image you wish to print.

2) Select **Image > Image Size**.

3) Uncheck **Resample Image** and then click in the box next to Resolution. The default setting

Notes

*The units shown for the **Document Size** will depend on how **Units & Rulers** is set in Photoshop's preferences. You can temporarily change the units used by clicking on the popup menu to the right of the Width and Height entry boxes.*

*If **Constrain Proportions** is unchecked only the dimension that you alter will increase in size.*

is 300ppi (or 118.11ppc). Alter the setting to 150ppi (55ppc). Note that the pixel size of the image does not alter, but the **Width** and **Height** values double.

4) Click OK to set the document to this new ppi/ppc value or add in your own values before clicking **OK**.

PHOTOSHOP: IMAGE SIZE
The same dialog box as on page 105, this time with the **Resolution** halved. Note that the **Pixel Dimensions** have not changed.

Cropping

A digital image can be cropped for a number of reasons. Probably the most important is to improve the composition. This is achieved either by effectively zooming into the composition by removing areas around the edge or changing the shape of the image entirely. The latter is particularly useful when the shape of the image doesn't match the shape of the paper you wish to print to.

There are two ways to crop an image in Photoshop: defining a selection and using the crop tool. Although the two methods are superficially similar, they are different. The one you use is largely personal preference, though there is a good case to be made swapping between the two methods when necessary.

Using the marquee tools

The marquee tools allow you to define an area in an image known as a selection (the area defined by the selection is shown by a shimmering line, widely known as "marching ants"). This has several uses. You can use a selection to define an area of an image that is to be copied, either to a new layer or to a new document entirely. Everything outside the selection is protected from editing, so you can use a selection as a way of applying local changes to an image.

You can also use a selection to define the area of an image that is to be cropped. The most useful of the marquee tools for this purpose is the **Rectangular** marquee found on the Tool panel. To use this marquee tool, it is simply a matter of selecting it from the Tool panel. You then left-click in the image in the corner of the area you want to select.

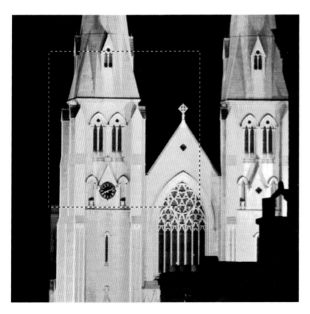

Keeping the mouse button held down, you then drag the selection until you reach the opposite corner of the area you want to select. Once you've defined the selection you can refine its position by pressing the cursor keys to move it around the image. You can also remove an area from a selection by holding down the Alt key and dragging a new selection so that it intersects with the first. To add to a selection you do the same, except you hold down the shift key instead.

Before you draw a selection there are several ways to control its behavior. The simplest is to hold down shift as you drag. This will constrain the selection to a square shape rather than an arbitrarily shaped rectangle. Another way to constrain the shape of a selection is to set the **Style** on the Control panel to **Fixed Ratio**. When you add numerical values to the **Width** and **Height** box to the right, the selection will be constrained to that aspect ratio. For example, if you enter in 3 to **Width** and 2 to **Height**, the selection will be constrained to an aspect ratio of 3:2, the same proportions as a standard image from a DSLR camera.

Once you have your rectangular selection defined you can then crop the image. To do this select **Image > Crop**. The image will then be cropped to the borders of the selection.

Tip

There are other options for defining the behavior of a selection on the Select menu.

CROPPING
This image was improved by cropping. The area shown in red was removed, leaving a tighter square image.

Using the Crop tool

Using the **Crop** tool is similar to defining a rectangular selection, in that you draw a box by clicking and dragging to set the area to crop to. However, it is far easier to refine the area once the cropping box has been drawn. By dragging the control handles on the edge of the box you can alter both the shape and size of the box quickly and easily.

As with making a selection you can also set the aspect ratio of the crop box. Unlike a selection however, you can specify a new resolution for the image, so that the image is shrunk to the correct size and shape for printing. If you have a lot of images that you need to prepare for printing, this is a very quick method of ensuring that they are all the correct size and shape. You can also define an angled crop box. When the image is cropped it will be rotated so that it is in a new orientation. Once you're happy with the size, shape, and angle of the crop box, press return to crop the image.

ANGLED
The ability to define an angled crop box is useful to radically alter the composition of images.

Sharpening

It is an odd fact but camera manufacturers deliberately soften images captured by a digital camera. This is achieved by a filter, known as an optical low-pass or anti-aliasing filter, which is fixed to the front of the sensor. The reason the filter is there is to avoid a problem known as moiré. This is the shimmering effect that can sometimes be seen in digital images of tightly textured subjects such as fabric. The practical upshot of this is that digital images have to be sharpened after capture. If you shoot JPEG, this is done in-camera. There is often an option that allows you to alter how much sharpening is applied, though it's rare to be able to turn sharpening off entirely. RAW files on the other hand are not sharpened and so any sharpening must be applied in postproduction.

Sharpening an image relies on a strange quirk of human vision. When sharpening is applied to an image, the contrast between edges (such as the edges between the text on this page and the paper) is increased. This isn't strictly true "sharpening," but does make the image appear sharper. The amount of edge contrast in an image is known as "acutance." The higher the acutance, the sharper the image will appear to be. However, it is possible to oversharpen an image. When edge contrast is too high, ugly halos will be seen around edges in the image.

SHARPENED
The photo on the left has had no sharpening applied, while the photo on the right has been oversharpened.

When an image is globally sharpened there is obviously an increase in sharpness across the entire image. However, not everything in an image benefits from being sharpened. Areas such as sky or skin tone can suffer when sharpened. If there is noise in an image this will be sharpened too, making the noise more apparent. Finally, if you've shot an image using JPEG (which will have been sharpened in-camera) and sharpen it further, any JPEG artifacts present will be sharpened too. So sharpening should be applied judiciously and only when necessary.

There are three stages of sharpening. The first stage is known as capture sharpening. This is subtle sharpening applied to an image to restore fine detail lost due to the limitations of lenses etc. Next is creative sharpening,

sharpening applied to improve specific areas of an image. One method of applying sharpening locally is to copy the image to a layer and then sharpen the layer. Once you've done that, add a layer mask to the layer. You can then "paint" out the areas of the image that should not be sharpened.

Finally, there is output sharpening, when an image is sharpened specifically for a task such as printing. When an image is printed using an inkjet printer, the ink will spread slightly on the paper, reducing sharpness. Output sharpening is therefore an important stage in preparing an image for printing.

SELECTIVE #1
I oversharpened this image to demonstrate the effect, but protected the sky by applying sharpening to a layer copy and then masking out the sky.

Smart Sharpen

Photoshop allows you to sharpen an image a number of different ways. By far the most useful and intuitive is **Smart Sharpen**.

1) Open the photo you want to sharpen, duplicate it, and resize the duplicate to the required print size (you can also close the original image at this point).

2) Select **Filter > Sharpen > Smart Sharpen**. Zoom into the image at 100% magnification. This is useful to see the effect that sharpening is having on the image. The **Amount** slider controls the degree of sharpening to the image. The higher the **Amount** value, the greater the increase in edge contrast, making the image appear sharper (though also increasing the presence of unnatural halos around the edges in the image). The **Radius** slider allows you to specify how many pixels surrounding edges in the image are sharpened. The higher the

Radius value, the further an increase in edge contrast spreads across the image.

3) **Remove** determines how Photoshop sharpens the photo. If your image is soft because it is slightly out of focus set **Remove** to **Gaussian Blur**. This won't rescue images that are completely out of focus, but it will go some way to sharpening a soft image caused by slight focusing errors. **Lens Blur** works in a similar way, though it is a bit more aggressive in finding edges in the image. Finally, **Motion Blur** attempts to reduce the blur caused by camera shake or movement during exposure. Set **Angle** to approximately the direction of motion blur in the image.

4) Check **More Accurate** to increase the accuracy of sharpening—with the penalty of Smart Sharpen taking slightly longer at sharpening the image.

5) Click on the **Advanced** button to fine-tune how the highlights and shadows in your photo are sharpened.

6) Click **OK** to apply sharpening to your image.

SELECTIVE #2 *(Opposite)*
I selectively sharpened the rocks in this image to bring out detail, but left the water unsharpened.

Canon EOS 5D, 50mm lens, 3 sec. at f/11, ISO 100

How much sharpening?

The amount an image needs to be sharpened by is largely dependent on the size of the print and therefore the average viewing distance of the print, the ppi value of the image, and the type of paper being used. Images generally need more sharpening the further the viewing distance is, the higher the ppi value, and when ink spread may be a problem—as it can be when matte papers are used.

All this means that there is no one set of figures that can be plugged into **Smart Sharpen** that will fit all eventualities. Sharpening therefore requires a certain amount of experimentation with different settings and with different types of paper. The aim ultimately is to produce a print that appears sharp, but without looking as though it has been sharpened.

DISTANCE
This image is oversharpened for the viewing distance in a book. However, if you prop open the book and move further away from it, the image no longer appears oversharpened.

PhotoKit Sharpener 2

One of the strengths of Photoshop is the fact that you can "bolt on" extra functionality in the form of plugins. There are now many third-party companies that supply Photoshop-compatible plugins that increase the usefulness of the software. PhotoKit Sharpener 2 by PixelGenius (www.pixelgenius.com) is one such plugin. PhotoKit Sharpener 2, for both Windows and Mac, is devoted entirely to the task of sympathetically sharpening images—removing the guesswork from the process. The plugin is split into three modules: Capture, Creative, and Output. This allows you to apply the correct level of sharpening required at each stage during your image processing workflow.

The Output stage is used specifically for preparing an image for print. Before you launch the Output module, the image must be resized to the size required for printing. In the Output module you first specify the

output device (typically this would be an inkjet printer, though there are also options that will sharpen an image for continuous tone printers such as dye-sublimation printers). Next you select the paper type, either **Glossy** or **Matte**. Click **OK** and a new layer is created; this layer is sharpened using the parameter you've selected, and control returns to Photoshop. Because PhotoKit Sharpener 2 creates a new layer, the sharpening is essentially nondestructive. If you don't like the results you can delete the layer or set the layer opacity so that the sharpening effect is reduced.

Tip

Generally you need to sharpen an image more for printing than you would if you were viewing it on screen only.

Manufacturer	Paper name	Description
Epson www.epson.com	Premium Semigloss	250g/m² • resin coated • Ultrachrome printers only
	Traditional Photo	300g/m² • acid-free • smooth gloss • Ultrachrome printers only
	Premium Luster Photo	250g/m² • slight sheen
	Double Side Matte	178g/m² • smooth matte • double sided
	Photo	190g/m² • gloss paper • suitable for most printing purposes
	Archival Matte	192g/m² • matte • Ultrachrome printers only
	Premium Semimatte	260g/m² • semi-matte finish • Ultrachrome printers only • only available on rolls
	Ultra Glossy	300g/m² • high gloss finish • Ultrachrome printers only
	Photo Quality	141g/m² • gloss finish • more suited for proofing images rather than longevity
	Premium Glossy	250g/m² • resin coated • gloss
Canon www.canon.com	Photo Paper Pro Platinum	300g/m² • high gloss
	Photo Paper Plus Glossy II	260g/m² • gloss
	Photo Paper Plus Semi Gloss	260g/m² • semigloss
	Glossy Photo Paper	170g/m² • gloss
	Matte Photo Paper	170g/m² • smooth matte
	High Resolution Paper	106g/m² • matte • more suited to draft printing or for printing graphic documents
	Fine Art Paper "Museum Etching"	350g/m² • 100% cotton rag • matte • produced for Canon by Hahnemühle
	T-shirt transfer material	Designed to be pressed onto material • Pixma printers only

Manufacturer	Paper name	Description
HP www.hp.com	Advanced Glossy Photo Paper	250g/m² • gloss
	Everyday Gloss Photo Paper	200g/m² • gloss • designed for general use
	Everyday Matte Photo Paper	135g/m² • matte • double-sided
	Premium Plus Glossy Photo Paper	300g/m² • gloss paper
	Premium Plus Semi-gloss Photo Paper	300g/m² • heavyweight • semigloss
	Premium Plus Satin Photo Paper	280g/m² • slight sheen • not suitable for use with Vivera pigment ink printers
	Professional Matte Paper	180g/m² • matte paper
Olmec www.innovaart.com/ de/olmec.html	Photo Gloss 260	260g/m² • high gloss • ultra white
	Photo Gloss 240	240g/m² • gloss • bright white • designed for general use
	Photo Satin 240	240g/m² • semi-matte • bright white
	Double-sided Photo Gloss 250	250g/m² • gloss paper • bright white • coated on both sides
	Matt Soft White Cotton 270	270g/m² • 25% cotton rag • matte • textured
	Photo Archival Matt 230	230g/m² • bright white • matte • smooth

Making a print

The image is prepared so now it's time to switch on the printer and select print, right? Unfortunately, there are still a few steps to go…

Perseverance

Being a photographer involves a series of meticulous steps, from finding the correct composition and exposure at the capture stage to refining the image quality in postproduction. Printing is merely an extension of this. Achieving a final, satisfactory print involves working through a number of very precisely defined stages.

A lot of photographers used to make notes when they produced prints in the darkroom. These notes would be a useful reminder of chemicals used, print exposure times, and other important snippets of information. This is a useful discipline for producing consistent digital prints. In this chapter I've described my personal workflow for producing a print. However, it's not the only possible one. If you experiment with Photoshop's print settings (and as an exercise it will help to understand the processes involved) it's a good exercise to make notes describing exactly what you've tried—and even why the settings did or didn't work.

MAKING A PRINT *(Opposite)*
As with most aspects of photography it's possible to develop a printing style that's as unique to you as your palm print.

CRAFTY
Like all crafts, digital printing requires practise and a willingness to learn from both success and failure.

Proofs

Making a proof is the term used by printers when making a test print. The test print is usually printed out using the same paper intended for the final print. It is a very methodical way to work and has much to recommend it. To save paper, smaller pieces can be used rather than a full-size piece—as long as the pieces are large enough that an accurate assessment can be made.

However, making test prints can be a laborious process, particularly if it takes making a few prints to work out any issues. Fortunately, Photoshop allows you to emulate the printing process on screen using a technique known as "soft proofing." Soft proofing temporarily alters the colors and brightness of an image so that it looks as it would when printed out on a particular paper. To use soft proofing you will need the relevant (and accurate) monitor and paper profile installed on your computer.

Soft proofing an image

1) Open the image that you want to print.

2) Select **View > Proof Setup > Custom**.

3) Click on the **Device to Simulate** popup menu and select the relevant paper profile from the list. Check both **Black Point Compensation** and **Simulate Black Ink**. Leave **Rendering Intent** set to the default. If you want to save these settings for future use click on **Save** and use an easily remembered name for the setting.

4) Click on **OK**. Your photo will generally now look much flatter than before. This is because paper does not have the dynamic range of a computer monitor.

SOFT PROOFING
Set to simulate Epson Heavyweight Matte paper.

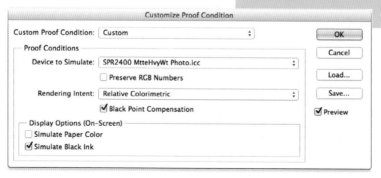

5) Select **View > Gamut Warning**. Colors on the monitor that cannot successfully be reproduced by your printer will be grayed out. Toggle the gamut warning using Shift+Ctrl+Y (Windows) or Shift+Cmd+Y (Mac) to see the changes more easily.

6) Turn off soft proofing by pressing Ctrl+Y (Windows) or Cmd+Y (Mac).

Successful soft proofing

Once you've switched on soft proofing you may find that you need to make color, brightness, or contrast adjustments to the image. However, make adjustments with soft proofing on and you can end up chasing your own tail. The most efficient way to use soft proof is to duplicate you image so that you have two copies of the image open (**Image > Duplicate**). You need

the two images to be at the same zoom level, so select **Window > Arrange > Match Zoom** and **Window > Arrange > Match Location**. Turn soft proofing off on one of the images and select the image with soft proofing switched on. Now use your preferred image adjustment tools to alter the soft proofed image so that it matches as closely as possible the non-soft proofed image.

LESS CLUTTER
Turn off Photoshop's various tool panels by pressing the Tab key. This will make the screen less distracting to look at as you work.

Printing

Once you've prepared your image it is time to print it out. The Photoshop Print dialog box is a confusing affair initially. However, once you understand how it all fits together there is logic to the order in which the options are selected. Some options are printer-specific. In the example below I've used an Epson R2400 printer. You'll find, however, that there should be similar equivalents for other models and brands of printers. The key to successful color printing is to let Photoshop handle color management, regardless of the printer being used (unless you don't have appropriate ICC profiles for the paper that you're using). When Photoshop is in control of color management

it will automatically convert your image to the correct printer profile when the image is printed. Later versions of Photoshop use a "document specific" approach to printing, so that you'll need to set up the printer for each separate image you want to print.

Print Settings: Photoshop CS6
1) Open the image you wish to print and then select **File > Print**.

2) Click on the **Printer** popup menu on the **Printer Setup** panel (1) and select your printer if it is not already selected. Set the number of copies you want to print (2) and adjust the orientation of the print if necessary (3).

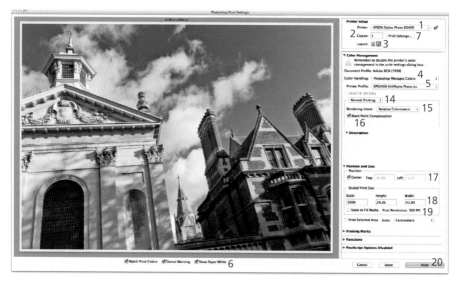

3) On the **Color Management** panel, click on the **Color Handling** popup menu (4) and set it to **Photoshop Manages Colors** (on Windows you will also need to check **ICM** and then set **ICC/ICM** to **Off [No Color adjustment]**). Choose the correct profile for the paper you're using from the **Printer Profile** popup menu (5). As a final test of color, check **Match Print Colors**, **Gamut Warning**, and **Show Paper White** (6).

4) Click on **Print Settings** (7).

5) Set the paper size to the size of paper you're using (8).

6) Select **Print Settings** from the popup menu (9).

Note
Prior to Photoshop CS6 some of the functionality of Print Settings is set via a separate menu option **File > Page Setup.**

7) Set the relevant **Media Type** from the popup menu (10)—Mac—or from **Paper & Quality Options**—Windows. Depending on the printer you're using some types of paper will not be listed. On the Epson R2400 for example, matte papers are not listed if a Photo Black cartridge is installed, and gloss papers are not listed when a Matte Black cartridge is fitted.

8) Select **Best Photo** (11) from the **Print Quality** popup menu.

9) For maximum quality (at the cost of slower printing) uncheck **High Speed** (12).

10) Click **OK** (Windows) or **Save** (Mac) to return to the main print dialog (13).

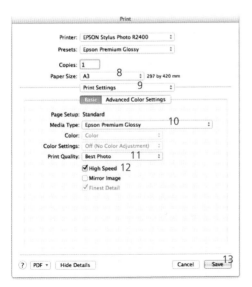

11) Leave **Normal Print** (14) set as it is. Leave **Rendering Intent** (15) set to **Relative Colorimetric**. Check **Black Point Compensation** (16) if it is not already checked.

12) You can move your image around the area of the paper (17). When **Center** is checked, the image will be printed in the center of the paper with an equal border on all four sides. When it is unchecked you can specify how far down the paper the image will appear by adding a value into the **Height** box, or a distance in from the **Left** of the paper's edge.

13) If you've not already resized your image before printing you can scale the image within the paper area by either altering the **Scale** as a percentage of the original image, or by specifying a new **Height** and **Width** (18). If you check **Scale to Fit Media**, Photoshop will automatically resize the image to fit the paper size (19), altering the ppi setting if necessary.

14) Click on **Print** to make your print (20).

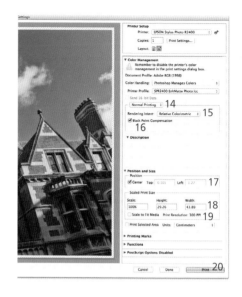

HARMONY *(Opposite)*
This image has a harmonious color scheme of yellows and greens.

Pentax 67, 150mm lens, exposure not recorded, ISO 50 (Fuji Velvia)

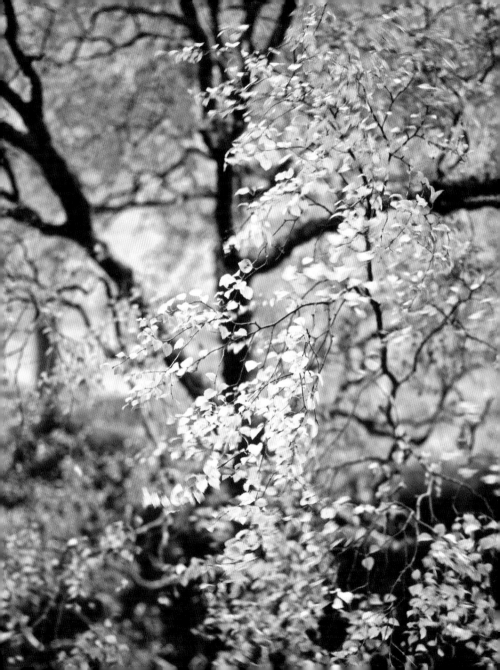

Basic Print Settings: Photoshop Elements 10

1) Open the image you wish to print and then select **File > Print**.

2) Click on the **Select Printer** popup and select your printer if it is not already selected (1). Set the paper size you're printing on to (2) and adjust the orientation of the print if necessary (3).

3) Select the **Print Size** from the popup menu to set the size of the image as it will appear on the page (4). Check **Crop to Fit** to crop the image so that it fills the selected Paper Size above (5).

4) Set the number of prints you wish to make by increasing or decreasing the value in the **Print x copies of each page** text-entry box (6).

5) Click on **Rotate 90° to the left** or **Rotate 90° to the right** to rotate the page. Check **Image Only** so that only the image is rotated (7).

6) Pull the slider left or right to zoom the image within the page (8).

7) You can move your image around the page (9). When **Center Image** is checked, the image will be printed in the center of the paper with an equal border on all four sides. When it is unchecked you can specify how far down the paper the image will appear by adding a value into the **Height** box, or a distance in from the **Left** of the paper's edge. Change the **Units** as desired.

8) Click **Print** (10) to make your print.

Advanced Print Settings: Photoshop Elements 10

1) Click on **More Options** (11) on the print dialog screen.

2) Click on **Printing Choices** (12).

3) If you want to print any of the **Photo Details**—the information taken from the metadata of your image—check all that are relevant (13). The information will be printed below the image on the page. If you print the image so that it fills the page, the **Photo Details** will not be printed.

4) If you're creating a transfer to be pressed onto a T-shirt, the image needs to be mirrored. Check **Flip Image** (14) if you have not already done this in Elements.

5) You can print a **Border** around your image (15), specifying the **Thickness** in a unit of your choice. You can also set the **Background** to a color other than the paper color.

6) If you plan to crop your image once it is printed, make sure that you check **Print Crop Marks** (16) so that guides are printed on the page to make this easier.

7) Click **OK** to return to the main print screen saving your choices (17), **Cancel** to return to the main print screen without saving your choices (18), or **Apply** (19) to save your choices before you click on **Custom Print Size** (20) or **Color Management** (21).

8) Click on **Custom Print Size** to set the size of the image on the page. Check **Scale to Fit Media** (22) so that your image is resized to fit onto the selected page size. Change the image size by altering **Height** and **Width** (23) using the desired Units (24).

9) Click on **Color Management**. Click on the Color Handling popup menu (25) and set it to **Photoshop Elements Manages Colors**. **Image Space** shows the current working space of the image (26). Choose the correct profile for the paper you're using from the **Printer Profile** popup menu (27). Leave **Rendering Intent** as **Relative Colorimetric** (28). Click on **OK** to return to the main print screen.

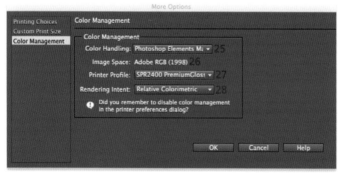

PREPARED *(Opposite)*
To prepare this image for the book I had to crop it to the right dimensions, resize it, and sharpen it.

Canon EOS 7D, 12mm lens, 1 second at f/13, ISO 100

After printing

The first twenty-four hours
Once you've made your print you need to resist the temptation to handle it. It may still be slightly wet and vulnerable to marking. Place the print in a dust free environment—and away from places where pets or children can reach it.

Always handle the print around the edges, supporting it from below with a smooth sheet of cardboard if it is a particularly large print. As the ink dries it releases a gas as the solvents in the ink slowly evaporate. This is not dangerous, but the solvents will condense again and leave a noticeable residue on glass. Therefore it is not a good idea to mount and frame a print immediately after printing. If possible, leave a print to dry for at least 24 hours. As a print dries it will darken slightly, so don't immediately dismiss a print if it seems a fraction too light.

The day after tomorrow
Once you're happy that your print is sufficiently dry, it's time to assess it critically. The light you view the print under will affect how the colors in the print are perceived. The most neutral light is a D50-compliant light. If you're serious about assessing your prints critically, there are commercial lightboxes designed specifically for this purpose. These lightboxes come in a variety of sizes, and the bigger the lightbox the more expensive it will be.

A cheaper solution is to view a print by the light of a north-facing window at midday. This is when daylight is at its most neutral in color (although this is not guaranteed, as weather conditions affect the color of natural light).

FLAT
No matter where you store prints, make sure that you keep them flat.

Whatever light you choose to view a print by, it should be as even as possible across the print. Softer, more diffuse light is better, particularly when viewing gloss prints. Small, hard lights will cause hotspots that can obscure detail.

When you inspect your print you should be critical in the best sense. Look first at the color. Is it accurate in comparison with the on screen image? If the overall color is wrong this could indicate a problem with either your monitor or printer profile. Next, check for printing problems such as banding or odd artifacts. Finally, look for problems with the image itself such as overall sharpness. If the print does have problems then these problems need to be solved before you reprint. Some other potential problems and their solutions are discussed in the troubleshooting section later in this chapter.

Storing prints

Prints need to be stored flat and in a cool, dry environment. The simplest solution is to use empty printer paper boxes to store prints in. A more expensive, but more satisfying, solution is to use a print cabinet. These are cabinets with wide, deep but relatively shallow draws. The advantage to using a print cabinet is that it is easier to file prints in a logical order, as well as to keep them safe.

To keep prints free from scratches, use sheets of tissue paper to separate them. The tissue paper should be acid-free to avoid damaging the print. For future reference, it is a good idea to write the date of printing and information about the paper stock on the back of the print. This should be done with pencil only as the ink from a pen may damage the print over the long term.

BOXED
I keep test prints for future reference in old printer paper boxes.

Mounting prints

Mounting a print is necessary if you plan to frame it at any point. The mount will stop the print from touching the glass in the frame. A mount consists of a sheet of backing board (known as the back-mat) to which the print is taped and a front-mat with a suitably sized aperture cut into it. Ideally the aperture should be slightly smaller than the image on the print. This will make it easier to align the print correctly and avoid any white gaps around the edges of the aperture. Both the back- and front-mat should be acid-free to avoid damaging the print. This applies to the tape used to attach the print to the back-mat. A framing store is the best place to find this tape. It is not recommended to use ordinary adhesive tape, as this is not archival.

The style of the front mat is very much a personal choice. White or a slightly creamy color works well for color images; white is preferable for black-and-white prints. If you do use a colored front-mat for a color print pick a color that's sympathetic to the print. Try to find a card color that matches a key color in the print, rather than a color that is entirely absent. The thicker the card used for the front mat, the more professional the result. Another aesthetically pleasing approach is to use two sheets of card for the front-mat, with the aperture of the card placed at the front slightly larger than the card next to the print.

DOUBLE-MAT
Adding two front-mats is aesthetically pleasing.

COLOR *(Opposite)*
Careful color management was important in the preparation of this book, from my system all the way through to the printing stage.

Pentax 67, 55mm lens, Exposure not recorded, ISO 50 (Fuji Velvia)

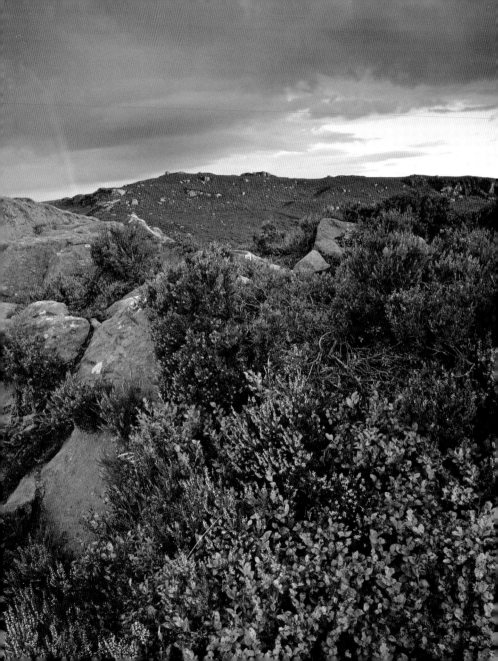

Troubleshooting

Although inkjet printers are robust devices things do occasionally go wrong. If a print doesn't turn out as expected, run through this list of common problems to see if there's an easy solution.

Uneven vertical lines
Vertical lines that have a jagged, toothlike appearance are a sign that the print head has moved out of alignment. The utility software that came with your printer will have a print head alignment option.

Regular horizontal gaps in the print
Ink can dry and clog the print head nozzles. If prints display regular horizontal gaps—or if the print looks as though there is color missing —this is a good indication that one or more of the print head nozzles is blocked. Your printer's utility software will have an option to perform a head cleaning routine. This uses ink, so it is not a good idea to run a head clean unnecessarily. Once the head cleaning process is complete, print out a test sheet to check to see whether the printer is back to normal. There is often the option in the utility software for printing out a simple page that uses all the print heads, making it easy to see which has a problem.

Using your printer little and often is the best way to avoid clogged ink nozzles. Some printers will automatically cap the print heads when the printer is switched off. This prevents ink from drying when the printer is not in use.

Soft or blurry prints
If you're using matte paper, this is often an indication that the printer has printed on the uncoated side, so that the ink has been absorbed more by the paper.

TESTING
The incomplete nature of this test pattern is a good indication that I need to clean the print head using my printer's utility software.

Ink blobs on the print

It is theoretically possible to use any type of paper in any inkjet printer. However, in practise some papers are more suitable than others. If a paper hasn't been designed for your printer the ink may not be absorbed, leading to it sitting on the surface of the paper. This tends to happen more with gloss paper than with matte paper, purely because matte is naturally more absorbent. The solution to this problem is to use a different type of paper.

Blank pages or random alphanumeric characters

Your printer needs to be connected to your PC all the way through to the completion of each print job. If the connection is interrupted, even for a split second, this can cause data corruption. A cable connection is generally robust but can be knocked out accidentally. If you're connecting to a printer via a Wi-Fi connection make sure that there is a strong signal between the two devices. Don't keep your printer too far from the router used to direct the Wi-Fi signal.

Paper jamming

Dust inside the printer can build up and start to jam paper as it passes through. Some paper, such as uncoated watercolor paper, can be a source of dust. If paper starts to jam regularly, clean the rubber rollers that pull the paper through the printer carefully with rubbing alcohol. When the printer isn't in use, keep the dust flaps closed or cover it with a plastic cover. Another sign of dust is when white specks start to appear on prints.

MAINTENANCE
The utility software that came with your camera will help you solve many problems with your printer's output.

Paper Profile:
St Cuthberts Mill

Ask any Briton what Somerset is famous for and the answer you'll get will invariably be cider. However, those in the know may mention paper instead. St Cuthberts Mill has been making paper since the 1700s. The mill is situated near the source of the River Axe, in the cathedral city of Wells. The water of the Axe is remarkably pure, which is a huge benefit when making fine-art paper. The current mill building dates from 1850 and is made from local stone. Two stone lions guard the entrance to the mill. Company legend has it the lions were brought back from Italy after an expedition there by the owner of the mill at the time.

St Cuthbert himself spent most of his life in 17th century Northumberland, in northern England. However, his influence spread across Britain. The mill is named after the parish of the local church. The cross that decorates the mill's artist papers is taken from the medieval cross on the outside of the saint's tomb in Durham Cathedral.

St Cuthberts Mill produces a wide range of fine-art papers, including paper specially coated for use with inkjet printers. The mill uses one of the few cylinder mould machines in the world to produce the paper in combination with natural woolen felts. ICC Profiles for a wide range of popular printers are available for St Cuthberts Mill Somerset Photo and Somerset Enhanced papers.

Manufacturer	Paper name	Description
St Cuthberts Mill www.stcuthbertsmill.com	Bockingford Inkjet	190g/m² • 100% wood free bleached chemical pulp • OBA & acid-free • watercolor CP (NOT) surface finish
	Somerset Photo	300g/m² • 100% cotton rag • OBA & acid-free • bright white • satin
	Somerset Enhanced	225g/m² • 100% cotton rag • acid-free • radiant white • satin, velvet, and textured surface finishes
Kodak www.kodak.com	Ultra Premium Photo	280g/m² • available in either high gloss or semigloss
	Premium Photo	250g/m² • available in either gloss or matte
	Photo	180g/m² • available in either gloss or matte
Museo Fine Art www.museofineart.com	Silver Rag	300g/m² • 100% cotton rag • OBA & acid-free • gloss • pigment ink printers only
	Portfolio Rag	300g/m² • 100% cotton rag • OBA & acid-free • smooth matte • optimized for pigment ink printers though can be used with dye ink printers
	Textured Rag	285g/m² • 100% cotton rag • OBA & acid-free • textured watercolor finish • optimized for pigment ink printers though can be used with dye ink printers
	Museo Max	365 & 250g/m² • 100% cotton rag • OBA & acid-free • velina finish • optimized for pigment ink printers though can be used with dye ink printers

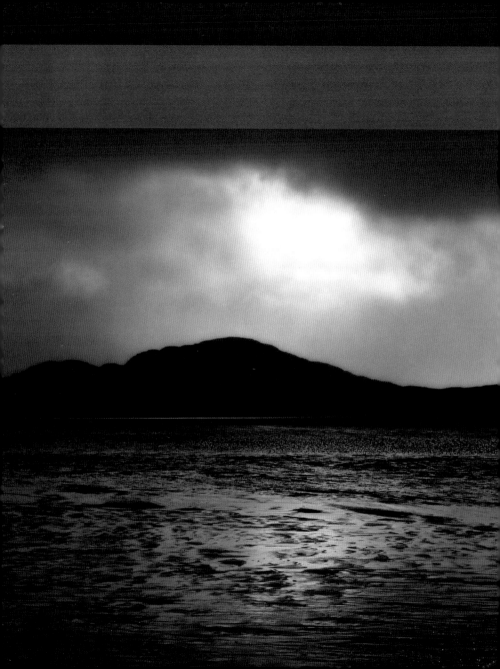

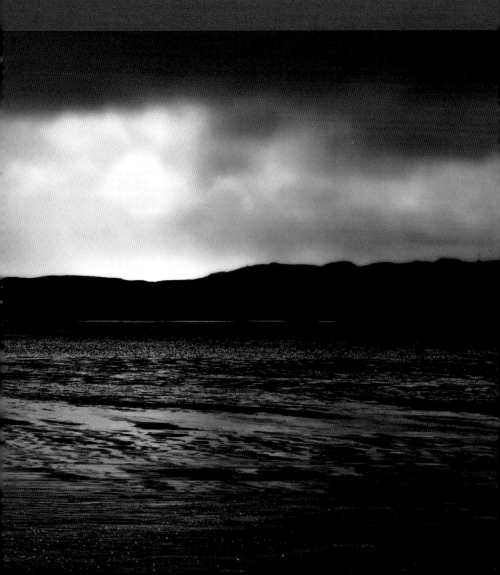

CHAPTER 6 BLACK AND WHITE

Black and white

Once upon a time photography was bereft of color. However, black and white photography shouldn't be seen merely as a lack of color, but as a creative way of working in its own right.

Darkroom vs. lightroom

It's fair to say that inkjet printers were scorned by a large number of photographers when they were first brought to market. This was partly due to the inability of early inkjet printers to match the aesthetic qualities of a good

darkroom black and white print. A darkroom Black and white print created by someone who knows what he or she is doing is a joy to behold. Now however, the latest inkjet printers are capable of rivalling—even surpassing—the subtle tonal range of a good darkroom print. This is partly due to improvement in inks and inkjet technology, but also in the development of papers suitable for black and white printing.

This has led to a resurgence of interest in black and white photography and is a very good thing indeed. Black and white is a less literal medium than color and so there is arguably more room for personal expression. Search the Internet with the term "black and white photography" and you will be assailed by many, many images in a wondrous variety of styles.

This chapter is a very short guide to a very big subject. However, it's a subject I personally find extremely compelling. Give it a go and you may find that you get hooked too.

VIVE LA DIFFÉRENCE
These two pictures are radically different in style. One is a "straight" landscape (left), the other a more stylized interpretation of the subject (right). Black and white photography easily encompasses either approach.

Tones

You'd be forgiven for thinking that a black and white image is just a color image with all the colors removed. To a certain extent this is true, though the success of a black and white image (and ultimately the print made from this image) depends on the method using to convert the colors to monochrome.

The maximum number of grays in an 8-bit image is 256, with black being the darkest and white the lightest. In the middle of this range is mid-gray with a value of 127, 127, 127. A subject that has an average reflectivity will be mid-gray when converted to black and white. Green grass is a good example of a subject that has an average reflectivity, as is blue sky

at midday, and ripe, red peppers. In color these three subjects are distinctively different. However, converted to black and white they will all be the same mid-gray. If you were to combine all three into one black and white image it would be difficult to distinguish one from the other tonally.

One way round this problem is to shoot black and white images using colored filters. A colored filter blocks out colors on the opposite side of a standard color wheel to the filter. As an example, a red filter blocks out blue-greens. With a red filter in place, any red in an image is lightened and anything blue-green is darkened.

COLOR
In color, the red of the car and the blue of the background are distinctly different.

Red filters have long been used by landscape photographers working in black and white to darken blue skies for this very reason. Green filters are most useful for portraits, since green helps to enhance skin tones. Using filters is all very well if you're shooting in black and white (either with black and white film or using your digital camera's black and white function). However, this is not an option if you wish to shoot in color and convert images to black and white in postproduction. Fortunately technology has come to the rescue. Photoshop has a number of tools for converting images to black and white. The most photographer-friendly tool is **Black & White** (**Image > Adjustments > Black & White**), which mimics the use of colored filters in a very intuitive way.

Tip

If you want to shoot in black and white in-camera you could use physical filters, although many cameras now have options that simulate their use.

SHADES OF GRAY
A simple removal of colors converts the red and blue to a roughly similar shade of gray (top). Simulating the use of a red filter in Photoshop lightens the red and darkens the blue (center). Simulating the use of a blue filter reverses the tonal relationship between the two colors (bottom).

Black and white conversion

Photoshop is like a Swiss army knife: there are tools for every purpose. Some tools seem to overlap, so it can be confusing to know which to use. This is particularly true when converting to black and white. I typically use the aptly named **Black & White** tool, although there are three other tools that are worth trying too.

Desaturation and Hue/Saturation

Selecting **Image > Adjustments > Desaturate** is by far the simplest way to remove color from your images. However, the price of this simplicity is that the tonal conversion often looks flat and there are no controls to rectify this.

Roughly the same effect can be achieved by selecting **Image > Adjustments > Hue/ Saturation** (or adding a Hue/Saturation adjustment layer to your image) and then dragging the **Saturation** slider down to -100. The one benefit of using Hue/Saturation is that you can easily tint your monochrome images by clicking on **Colorize** on the Hue/Saturation dialog box. Now you can use the **Hue** slider to add a color tint globally across the image and the **Saturation** to adjust the vibrancy of the selected color tint.

COOL
To create this monotone image I used Hue/Saturation, switching Colorize on and using a value of 228 for Hue and 18 for Saturation.

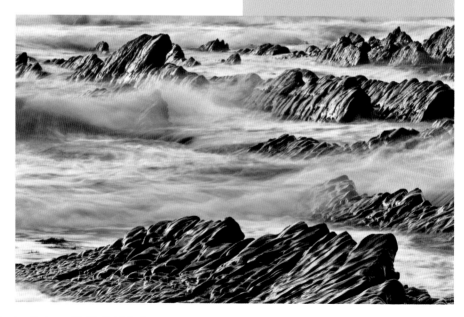

Channel Mixer

As mentioned in chapter 3, each pixel in a digital image is made up of a combination of red, green, and blue channels. The **Channel Mixer** tool allows you to finely control how much each of the three channels is allowed to add to the brightness of each pixel in your black and white image.

Using Channel Mixer

1) With an image open select **Image > Adjustments > Channel Mixer** or add a Channel Mixer adjustment layer.

2) Check **Monochrome** at the bottom of the dialog box. If **Preview** is checked, your photo should now be converted to black and white.

3) Next, move the relevant **Source Channel** slider to adjust the percentages contributed by the **Red**, **Green**, and **Blue** channels. The **Total** percentage is shown below the sliders. A total greater than 100% will cause clipping in the highlight details of your photo: less than 100% will cause clipping in the shadows. If you make an adjustment to one slider, you will have to make an opposite adjustment to one or both of the other two to maintain the correct tonal range.

4) The **Preset** popup menu has a range of default settings that mimic the effects of using different color filters. Selecting one of these presets will set the channel sliders automatically to the relevant **Red**, **Green**, and **Blue** mix.

5) Moving the **Constant** slider to the right will lighten your photo. Moving it to the left will darken it.

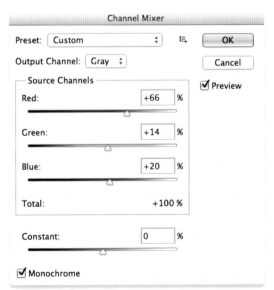

Black & White

The **Black & White** adjustment tool is a relatively recent addition to Photoshop, but it allows very fine control of your black and white conversions. The filter works by allowing you to adjust how light or dark individual colors will be when converted to black and white. This mimics the way that photographic filters work when shooting black and white images in-camera.

1) With an image open, select **Image > Adjustments > Black & White** or add a **Black & White** adjustment layer. The image will be automatically converted to black and white. If you click on **Auto**, Photoshop will automatically adjust the black and white tones reasonably sympathetically based on the original colors in the image.

2) If you'd prefer to adjust the tonal range manually, use the sliders to adjust how individual colors are converted. The more you move a slider to the right, the lighter that color will be when converted to black and white; the further left it is, the darker the color will be.

3) The **Preset** popup menu has a range of default settings that mimic the effects of using different filters and film types, such as infrared.

4) If you want to save a particular color mix, click on the Preset icon to the right of the drop-down menu (at the top of the adjustment layer panel if you're using an adjustment layer). Select **Save** and enter a relevant file name.

5) If you select **Tint** you can tint your black and white image in a similar way to **Colorize** when using **Hue/Saturation**.

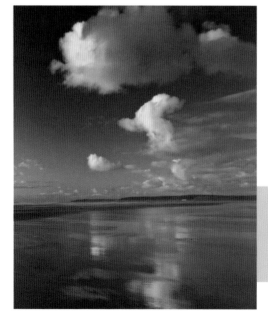

RED, GREEN, AND BLUE
The image (left) has been converted (right) using three different Black & White settings, L–R: using the Red Filter preset; the Green Filter preset; and the Blue Filter preset.

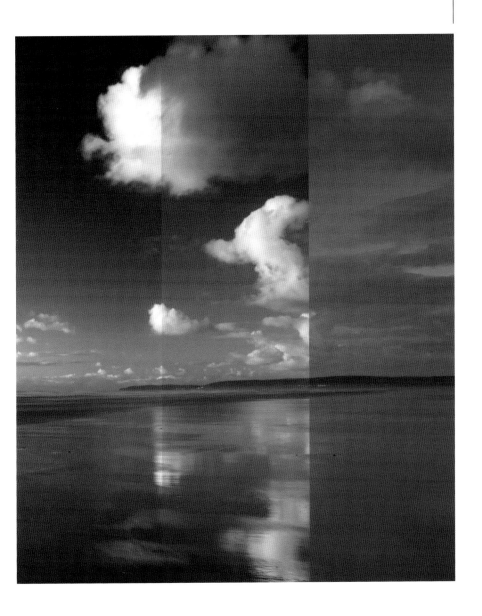

Printing black and white

Black and white printing can be marred by prints exhibiting an overall color cast. This is due to the fact that some inkjet printers use all the inks to create the black and white image. The success of a black and white image is therefore more dependent on the sophistication of your printer than when making color prints. Generally, the greater the number of black cartridges (such as black, light black, and even light light black) the more successful a printer will be in creating neutral-looking black and white prints. One way around this problem is to replace all the color cartridges with a set of cartridges that only contain gray ink.

Print Settings for black and white: Epson printers

1) Open the image you want to print and the select **File > Print**.

2) Unlike when printing in color, it is better to let the printer itself take care of the black and white color management, rather than Photoshop. Click on the **Color Handling** (1) popup menu and select **Printer manages color** (alternatively worded as **Let Printer Determine Colors**). Set **Rendering Intent** (2) to **Relative Colorimetric** if it is not already.

3) Click on **Print Settings** (3).

4) If you are using a Mac, set **Color Matching** to the (Your Printer) Color Controls.

5) Set **Color Management** (Windows) to **Advanced B&W Photo** or on **Print Settings** set Color to **Advanced B&W Photo** (Mac) (4).

6) Under **Paper & Quality Options** set options to match the paper type and size you are printing to (Windows) or set **Media Type** (Mac). Select **Best Photo**.

7) You can control how **Neutral** your print is, or whether the print is printed **Cool**, **Warm**, or **Sepia** from the **Color Toning** popup menu.

8) To fine-tune the settings click on **Settings** (Windows) or on **Advanced Color Settings** (Mac) (5). The settings allow you to adjust **Tone** of the print, making it **Darker**, **Dark**, **Normal**, or **Light**. You can also adjust settings such as **Shadow Tonality** and **Highlight Tonality**, which attempt to preserve details in the shadows and highlights of your prints respectively. **Max Optical Density** adjusts the density of the blacks in your print.

9) Click on **OK** (Windows) or **Save** (Mac) to return to the main print dialog box. Click on **Print** to make your print.

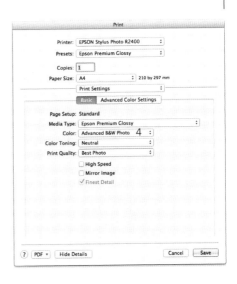

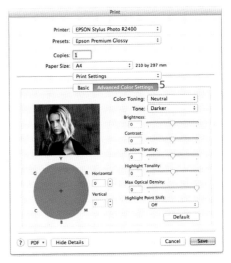

Traditional Black and White Effects Digitally

One of the joys of working in the darkroom is trying different papers and photographic processes. Many of these processes can be emulated digitally, without the need for working with trays of chemicals.

Cyanotypes

Most traditional photographic paper uses silver halides as the light-sensitive base. The cyanotype process is slightly different in that it uses a mixture of iron salts (mainly ferric ammonium citrate) and a second chemical (often potassium ferricyanide). When combined, and exposed to UV light, the reaction of these two chemicals together produces "Prussian Blue," the color that gives cyanotype prints their distinctive cyan-blue tint. The longer the cyanotype is exposed to UV light, the deeper the color of the final print.

One of the first photographers to use the process was Anna Atkins. From 1842, Atkins laid plant and seaweed specimens on sensitized paper, which was then exposed to UV light (in the form of sunlight). The inverted silhouettes that were created have long been admired for their delicacy and artistry.

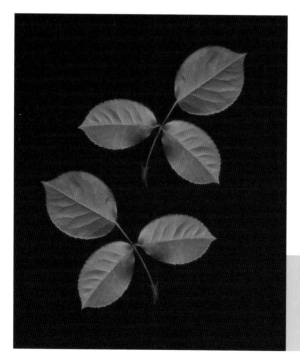

SCANNED
This image was created by scanning rose leaves on a flatbed scanner to emulate Atkins' contact printing technique.

Creating a cyanotype

1) Open a color image. Cyanotypes work well with images that have a simple composition and good contrast range.

2) Add a **Channel Mixer** adjustment layer to the image and check the **Monochrome** button on the Channel Mixer dialog box.

3) Move the sliders so that the monochrome image looks pleasing. Remember that if the mix of the three channels is greater than 100%, the highlights will be lost. Generally, increasing the

amount of blue compared to red and green will create a more authentic cyanotype image. Click on **OK** (if required—later versions of Photoshop don't require this step).

4) Add a **Curves** adjustment layer to the image. Move the new layer above the **Channel Mixer** layer if it isn't already.

5) Select the **Red** channel from the **RGB** popup menu and pull the curve downward so that it forms a gentle arc. Then, select the **Blue** channel from the popup menu and push the curve upward, again so that it forms a gentle arc. Click **OK** (if required).

6) Add a **Solid Color** adjustment layer. Set the color to RGB: 00, 30, 50. Click **OK**. Set the Blend mode of the layer to **Color**. Pull the adjustment layer down so that it is directly above the **Background** layer. Adjust the opacity of this layer to suit.

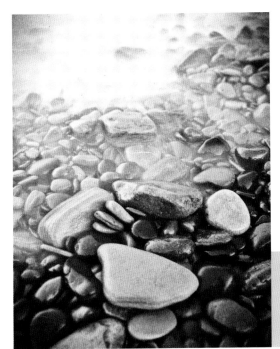

ROCKS
If there are bright highlights in an image, particular care must be taken with the proportions of the color mix.

Split-toning

A split-toned black and white image is one that uses a color tint for the highlights and a different color tint for the shadows. In the darkroom this was achieved by washing the print in special chemical solutions after the print had been developed. Generally the split-toning effect works best with two color tints that are very different from one another. A good example of this is when a warm color, such as yellow, is used for the highlights and a cooler color, such as blue, is used for the shadows. However, like much of photography there is no right or wrong answer. You should experiment to find your own personal preferences.

Creating a split-toned image

1) Open an image that you've already converted to black and white. This technique works better with images with a good tonal range rather than images that have a high inherent contrast.

2) Add a **Hue/Saturation** adjustment layer to the image. Don't alter any settings but click on **OK** to continue (whether you need to do this will depend on the version of Photoshop you're using). To make life easier later on, rename the layer Shadow.

3) Next, add another **Hue/Saturation** adjustment layer above the first. Again, don't alter any settings but click on **OK** to continue (if required). Rename this layer "Highlight."

4) Click on the layer mask of Highlight so that you can edit it, and then select **Image > Apply Image**. Don't alter the default values. Click **OK** to continue.

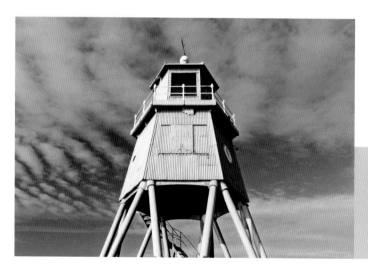

SIMPLE
Simple images are generally more effective when applying a split-toning effect.

5) Double-click on the **Hue/Saturation** icon on the Highlight adjustment layer (again this will depend on the version of Photoshop you're using—on more recent versions just click once on the icon). Check **Colorize** and then adjust **Hue** so that the highlights are tinted the required color. Click **OK** to continue (if required).

6) Click on the layer mask of Shadow so that you can edit it and then select **Image > Apply Image**. Don't alter the default values. Click **OK** to continue. Then select **Image > Adjustments > Invert** so that the tonal range of the layer mask is reversed.

7) Double-click on the **Hue/Saturation** icon on the Shadow adjustment layer (if required). Check **Colorize** and then adjust **Hue** so that the shadows in the image are tinted the required color. Click **OK** to continue (if required).

8) You can adjust the balance of the highlight and shadow by adjusting the **Saturation** sliders of the adjustments layers.

9) Flatten the image, once you're happy with the effect, and save it.

LAYERS
The layer stack when creating the image on the opposite page. In this instance I've applied a Black & White adjustment layer to the stack. If you do this, make sure it is below the two Hue/Saturation adjustment layers.

Soft focus

Photographers can be perverse at times: Sharpness is one quality that defines the usefulness of a lens, but then that quality is reduced by the use of filters such as a soft focus filter. The reason you'd use a soft focus filter is to hide fine detail in an image, which is often—though not exclusively—something done when shooting portraits, as a soft focus filter will reduce the appearance of wrinkles and blemishes on a person's face.

As with all physical filters, once you've taken the shot it's not easy to remove the effect afterward. Therefore you'll have more control over a soft focus effect if it's applied in postproduction. Although soft focus effects work well with color imagery, they are most effective when used with monochrome images.

Applying a soft focus effect

1) Open an image that you've already converted to monochrome. This technique works best with images that are reasonably high in contrast.

2) Make a copy of the **Background** layer by dragging the layer down to **Create a new layer** icon at the bottom of the Layers panel.

LIGHTS
Soft focus works well when you have point light sources in an image.

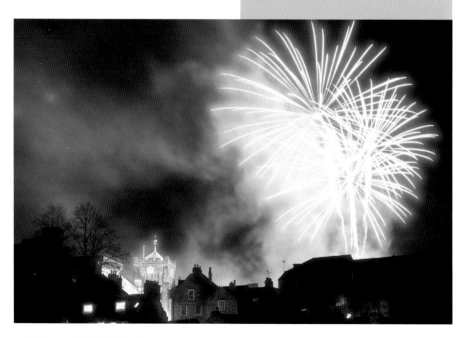

3) Select **Filter > Other > Maximum**. Adjust the **Radius** value either by dragging the slider or by adding a numerical value into the box to the left of **Pixels**. The radius you use will depend on the pixel resolution of your image. For an image approximately 3000 x 4500 pixels or higher use a radius value between 35 and 45. Images with a smaller pixel resolution don't need such a high radius value. Click **OK** to continue.

4) Select **Filter > Blur > Gaussian Blur**. Set the **Radius** value to half that used with the **Maximum** filter.

5) Set the **Opacity** of the background copy layer to between 20% and 40%. The higher the value, the more pronounced the soft focus effect will be.

6) As an extra refinement, add a layer mask to the background copy layer. Set the **Foreground color** to black and then use the **Brush** tool to paint in any areas you want to remain sharp.

7) Flatten the layers together when you're happy with the soft focus effect.

DETAIL
Soft focus effects tend to smother very fine detail.

Noise

There's something very atmospheric about a grainy black and white photo, but modern digital cameras are very good at producing clean, noise-free images. Therefore, if this is the effect you wish to achieve, grain needs to be added back into an image in postproduction. The simplest way to do this is to use Photoshop's noise filter, although there are several plugin filters for Photoshop that can mimic the grain characteristics of specific black and white films.

Adding grain

1) Open an image that you've already converted to black and white. This technique works best with images that are relatively low in noise.

2) Select **Filter > Noise > Add Noise**.

3) Click on the **Monochromatic** button at the bottom of the **Add Noise** dialog box.

4) Click on the **Gaussian Distribution** button.

5) Move the **Amount** slider to the right to increase the appearance noise in the image. The higher the value, the more that fine detail in the image will be lost.

6) Click on OK when you're satisfied with the amount of noise in the image.

NOISY
This image has had noise applied and then a subtle sepia effect added using Hue/Saturation.

FILM *(Opposite)*
Plugin filters such as Exposure 3 by Alien Skin allow you to mimic the characteristics of specific film types.

Canon EOS 7D, 50mm lens, 1/250 sec. at f/2.2, ISO 800

Manufacturer	Paper name	Description
Moab www.moabpaper.com	Anasazi Canvas Premium Matte	350g/m² • polycotton • white
	Colorada Fiber Gloss	245g/m² • alpha cellulose • acid-free • bright white • gloss
Note Moab papers are optimized for pigment ink printers though they can be used with dye ink printers	Colorada Fiber Satine	245g/m² • alpha cellulose • acid-free • bright white • semigloss
	Entradra Rag Bright	300/190g/m² • 100% cotton rag • acid-free • bright white • double-sided
	Entradra Rag Natural	300/190g/m² • 100% cotton rag • acid-free • natural white • double-sided
	Slimrock Metallic Pearl	260g/m² • resin-coated • acid-free • natural white • semigloss • metallic finish
	Moenkopi Washi Kosho	110g/m² • mulberry • natural white
	Moenkopi Washi Unryu	55g/m² • mulberry • natural white
	Lasal Photo Exhibition Luster	300g/m² • resin-coated • ultra white • semigloss
	Lasal Photo Gloss	270g/m² • resin-coated • brilliant white • gloss
	Lasal Photo Matt	230g/m² • wood pulp • brilliant white • matte
	Entradalopes	190g/m² • 100% cotton rag • bright white • double-sided • blank greetings card (folded)

Manufacturer	Paper name	Description
Ilford www.ilford.com	Galerie Prestige: Gold Fibre Silk	310g/m² • Baryta • pigment ink printers only
	Galerie Prestige: Smooth Pearl	310g/m² • heavyweight • semigloss
	Galerie Prestige: Smooth Pearl	290g/m² • semigloss
	Galerie Prestige: Smooth Gloss	310g/m² • heavyweight • gloss
	Galerie Prestige: Smooth Gloss	290g/m² • gloss
	Galerie Prestige: Smooth High Gloss	215g/m² • high gloss • dye ink printers only
	Galerie Prestige: Smooth Lustre Duo	280g/m² • resin-coated • semi-gloss • double-sided
	Galerie Prestige: Smooth Fine Art	190g/m² • 100% cotton rag • acid-free • textured • matte
	Galerie Prestige: Smooth Fine Weave	210g/m² • textured • matte
	Galerie Prestige: Smooth Fine Art Matt	310g/m² • 100% cotton rag • heavyweight • calendered • matte
	Galerie Prestige: Smooth Fine Art Canvas	375g/m² • polycotton stretchable canvas
	Galerie Premium: Lustre	270g/m² • semigloss
	Galerie Premium: Gloss	270g/m² • gloss
	Galerie Premium: Lustre Duo	220g/m² • semigloss • double-sided
	Galerie Premium: Heavyweight Matt	200g/m² • matte

Beyond the printer

There is more to printing than just making prints. This final chapter explores other ways to use your digital images.

A wealth of choices

You've made a print. What do you do with it? There is something melancholy about the thought of prints being stuck in a box, out of sight and out of mind. If you've taken the time to prepare an image and then spent money on ink and paper to print it, shouldn't others see it? The question is slightly trickier than you may think. Prints, and by extension your images generally, will be very personal to you. It can be a nerve-wracking experience to let others, apart from close friends and family, see your work. In doing so, it's almost like you're putting yourself

on display. Some people are obviously more outgoing and will find this easier, but initially it will still feel unnatural.

This chapter covers three of the ways you can bring your photography to a wider number of people. They are three ways that I've explored over the past few years. And yes, it did feel unnatural the first time I showed my work outside my immediate social circle. But, it was worth persevering. My understanding of photography has grown since then. People are generally honest about what they do and don't like, and this has been invaluable in my own development as a photographer. Sometimes a careless comment can hurt, but these moments are usually far outweighed by the positives.

EXHIBITION *(Opposite)*
It's not just arty types who can hold an exhibition.

PROJECTS
If you have worked on a personal photography project, consider sharing it with the world.

Making a book

Handmade

The creation of a book of your photographs is a particularly satisfying process. In compiling items for a collection, you will learn to be critical of your own work—you will wish to include only your best images—and enjoy the creativity of choosing work with a cohesive theme or style, or a logical timeline.

Perhaps the simplest handmade book form consists of two hard covers with separate "hinges," which enable the covers to open.

The pages of photographs, either single or double-sided, are then hole-punched and bound with bookbinding posts. These are readily available online from bookbinding suppliers.

If you're feeling more adventurous, it's possible to stitch the pages and covers together by hand. It's good fun to choose a color scheme for your book, with coordinating cover papers and materials for the bindings, and this all adds to the personal feel of your book.

Handmade books are not only extremely satisfying to create, but they can make wonderful gifts and keepsakes. A book made up of images that are personal to the recipient —such as photographs of their wedding, for instance—will almost certainly be treasured for a lifetime, and could even be handed down to future generations.

PERSONAL TOUCH
Handmade books are very personal items and can be as simple or as elaborate as you like.

Commercial

The alternative to making a handmade book is to create a photobook, either using an online service or high-street store. Companies that print photobooks typically offer a range of book sizes and paper types. There is generally a compromise to be made between cost and the number of pages in a book, the paper quality, and the binding (hard, cloth-bound covers are more expensive than printed soft covers).

Most photobook printers will offer a range of templates to make the design process easy. A good template should offer the ability to add text onto a page so that images can be captioned. The one drawback with using a template is that your photobooks won't necessarily reflect the character of you or your images. Some photobook publishers allow you to upload your own books in the form of a PDF. Creating a book this way does require some knowledge of layout and design, but the resulting book can be personalized far more easily. A book that is a PDF can also be distributed more easily to PCs and tablet devices such as the iPad, too.

The printing time varies from company to company but ten working days is not uncommon. If you intend to create a book as a gift you'll need to think ahead. A month is the minimum recommended period to allow for any problems with printing the book.

ROARING SUCCESS
Creating a photobook is a great way to finish themed projects. This is a book about lions that I'm slowly working on just for fun.

Terminology

Most book printing web sites generally keep things simple and don't use too many confusing technical printing terms. However, it's worth taking time to understand some of the more basic concepts, since they will be relevant when you are designing your book.

Alley

Blank space between two columns of text.

Binding

The method used to join the pages of a book together. This can be achieved one of several ways, depending on the thickness of the book. The simplest method is using staples, though this is less effective for thicker books. A more effective method once a book reaches a certain size is to bind the pages together

with glue. However, this makes a book difficult to open fully.

Bleed

Books are usually printed slightly larger than required. This excess area is then trimmed away so that the book is the correct size. However, the trimming process isn't always precise. If you have an image that fits to the edge of the page this may lead to a white line running down the page edge. A bleed is when an image is extended outside the intended dimensions of the book at the design stage. This allows for any inaccuracies during the trimming stage. The bleed is typically

BLEED & CROP
The area covered in light diagonal stripes is the bleed I used when creating this page using Adobe InDesign. The inner of the two vertical and horizontal marks at the top left of the page show how the page should be trimmed after printing.

2–5mm along each outside edge, though your intended book printer should be able to supply the exact dimensions required.

Gutter
Once a book has been bound it may become difficult to open fully. This will make it difficult to see images or text clearly if they are placed close to the spine. A gutter is a margin or blank space on the inside of the page that allows for this. The type of binding used will determine how large the gutter needs to be.

ISBN
Companies such as Blurb and Lulu allow you to sell your book through online bookstores such as Amazon. However, your book will need to have an ISBN, short for International Standard Book Number. Every commercially sold book has a unique ISBN, allowing books to be cataloged and identified more easily. ISBNs are either 10- or 13-digit numbers.

Laminate
A thin, glossy coating typically applied to book covers to make them more robust.

PDF
Short for Portable Document Format. Developed by Adobe, this is the standard digital file accepted by most printers when submitting a book design.

Proof copy
If you intend to sell your book commercially, it is a very good idea to order a copy before it goes on sale. This is known as a proof copy and will allow you to check that colors are correct and that the spelling and grammar in the text are accurate.

GUTTER
The area of light diagonal stripes is the gutter down the middle of a two-page spread. When designing this book I made sure that no text entered the striped area.

Case Study: the St Cuthbert's Way

Over the course of 2007 I documented photographically the St Cuthbert's Way—a long-distance route across the Scottish Borders and northern England. The aim was to create a self-published book through Blurb for anyone who had also completed the walk.

I decided early on that the images would be sequenced geographically as far as possible —though I was prepared to swap images around if a particular order seemed more pleasing. The route is commonly walked over four days, so that immediately suggested that the book should have four chapters.

The first step was to edit my selection of photos. The impact of a book will be lessened by the use of weak images. I was therefore ruthless in which of my images made it into the book. If an image didn't work technically or aesthetically it was rejected.

Rather than use one of Blurb's many book templates, I created my book using Adobe InDesign (I still had to use one of the available book sizes that Blurb can print, though). Creating my own design took time, but fine-control over the entire design was important to me. What I did have to do though was carefully read through Blurb's "rules" for creating a book. This meant being very precise with aspects of design such as leaving a sufficient bleed area around images. It also meant converting my images to CMYK and using the ICC profile that Blurb supply, to ensure accurate color.

ADOBE INDESIGN
Designing the layout.

Once I'd taken account of these rules, the design was entirely up to me. The key when designing a pleasing book is consistency. A design that changes from page to page is distracting and will reduce the appreciation of the images.

It's not a good idea to use a wide variety of fonts when designing a book. If you do want to use a few different fonts, try and use ones that are reasonably similar—mixing a serif font such as Times Roman with a sans-serif font such as Arial on a page can be particularly jarring. For the St Cuthbert's Way book I used Garamond for the main text and Footlight MT light as they work well together. The font for the main text should be easy to read. Thin fonts look modern and are ideal for large titles but they can be difficult to read once they're shrunk to the right size for the main text. The book you're reading now uses Frutiger, which is a modern sans serif font and is very readable.

Using bright colors for text or background can also detract from your images. If you want a colored background, use a color that's sympathetic to the accompanying image. Picking a color from the image often works well. If you're using a commercial printing company such as Blurb, you may need to convert the images used in the book to CMYK. Highly saturated colors don't translate well to CMYK so are best avoided. To add interest to the text in the St Cuthbert's Way book I used black, gray, or white depending on the background color of the page. However, again I did this in a consistent fashion, rather than arbitrarily.

Less is often more when creating a page layout. It is tempting to cram as many images onto a page as possible. However, more than

POSITIONING
The red line in this image represents the spine of the book. For this double-page spread I kept the most important elements away from this area.

Along the Tweed

two images on a page is unwise—particularly if you're using a small book size. If an image doesn't fill a page leave space around it, so that it has "room to breathe." There's something slightly disconcerting about an image that almost fills a page, but doesn't quite fill it. A double-page spread is a very effective way to create an impact. However, don't use images in which the subject is central as it will be lost in the spine of the book.

The cover of a book is first thing a reader will see. It has to encourage the reader to look inside the book, so the design is important. If you use an image on the cover, it has to be representative but striking at the same time. It's not a good idea to use too busy an image, partly because it will lack immediate impact,

and partly because it may be difficult to place the title and other details so that they can be read easily. A cover image will benefit from an area or two empty of detail for this very reason. The cover image for the St Cuthbert's Way—the Eildon Hills in the Scottish Borders—wasn't shot from a point on the walk itself. However, it is representative of the landscape that is walked through and is a recognizable landmark of the area.

Finally, you need to take account of the thickness of the book when designing your cover. Companies such as Blurb feature tools that help you calculate how wide the spine should be depending on how many pages you've used.

BOOK 'EM *(Opposite)*
Creating a book from a long-term project is a great way to bring it to a satisfying conclusion.

Canon EOS 5D, 24mm lens, 1/4 sec. at f/11, ISO 100

COVER STORY
The cover is usually designed so that it can be wrapped around a book in once piece. This means that the front cover should be placed to the right of the design.

St. Cuthbert's Way
A Photographic Journey

David Taylor

Greetings cards

Everyone likes to receive a greetings card, whether it's for a special occasion or just because someone wants to cheer you up. Making greetings cards out of your own images makes the process a touch more personal.

There are three methods for creating greetings cards; the first is to print out a card design using standard paper and then trim and fold as necessary. The second method is to buy a blank greetings card and print directly to that, or to a suitably sized piece of paper and then stick this to the card. The third method is to use a commercial company. Online photo printers often offer this as one of their services. The advantage of producing a greetings card this way is that there will be a template to work to and often the price includes a correctly sized envelope.

The first method does involve more work but is the most flexible in terms of the size of the card you can produce—though you have to be careful that your card will still fit into a standard size envelope. The card size when folded has to be slightly smaller than the envelope—particularly if you're using thicker paper. This method is also not suited to using gloss paper. Firstly, many paper manufacturers print their logo across the backs of gloss papers and secondly, the surface of the paper is often difficult to write on as it usually has a slightly waxy finish.

STORMLIGHT *(Opposite)*
This image has proved to be a popular greetings card. Although it's a much photographed subject, the drama of the light is attractive to people.

Canon EOS 7D, 17mm lens, 1/3 sec. at f/18, ISO 100

HORIZONTAL
This is a greetings card designed to sit horizontally. Note that the main image is rotated 180° to the text that appears on the back.

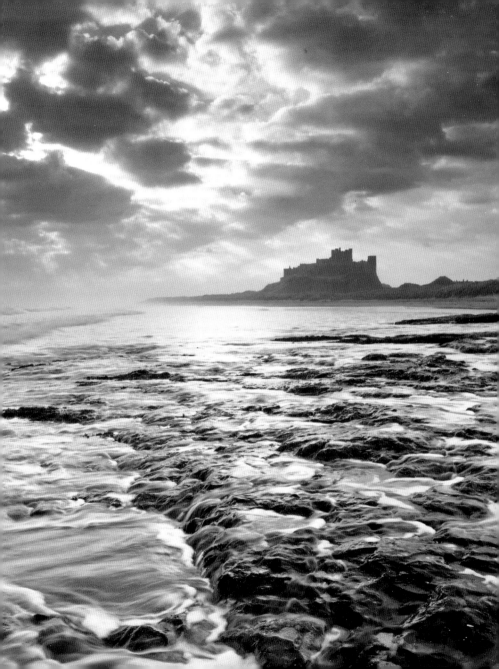

If you do create a card using this method it's a good idea to build very faint crop lines into the design. This will make the trimming process far easier. The image on the front of the card needs to be on the right of the fold line, and any information about you or the card goes on the left. This is true whether you're creating a tall vertical card or one that sits horizontally. The one difference between vertical and horizontal cards is that the image and text on a vertical card should both be vertical and in the same orientation; the image on the front and the text on the back of a horizontal card should be facing in opposite directions.

Subjects

If you're producing a one-off card for someone special it's generally easy to pick a subject. It would usually be something that is recognizable or has relevance to that person. However, there's no reason not to bring your cards to a wider audience.

Local stores are often amenable to selling greetings cards made by individuals. In this case, the most obvious subjects are local landmarks, particularly ones that have a high appeal to tourists. However, these places are often over-photographed so you may find that there is competition from other photographers. If this is the case you need to use an image that either takes a different slant on the subject or that is aesthetically more pleasing than the competition. This means being honest with yourself as to whether your image makes the grade. Cards that "tell a story" are popular. People often read meaning into an image that didn't occur to you. You may think a sunset is a sunset, but it could be the perfect card for someone who is retiring, for instance.

ALLEGORICAL
This image has proved popular as a greetings card because it can be interpreted in a number of different ways.

Hosting an exhibition

Making prints that no one but you ever sees can be perfectly satisfying. However, this satisfaction doesn't compare to the satisfaction that can be had by hosting a successful exhibition.

In many ways, putting on an exhibition is like putting together a book. An exhibition doesn't necessarily need an overall theme, but it does help. And, like a book, an exhibition should be composed only of your very best work.

Once you have a coherent theme and representative portfolio, you'll also find it easier to persuade gallery owners to host your exhibition. Gallery owners are professionals and so you need to be professional in your dealings with them. If you're vague about your photography, or show weak material, you won't get anywhere. Another common mistake is to show your portfolio to the gallery owner and then criticize its shortcomings. If you don't like your work, why should the gallery owner?

Once you've secured gallery space you'll be able to work out how many images are needed to fill it. It's tempting to shoehorn as many images in as possible, but this is often counterproductive. Showing fewer images allows each individual image room to breathe. If images are crowded together the impact of individual images is lessened appreciably. Less is often more when it comes to putting an exhibition together.

THEMES
There's not much thematic unity between these two images. It's doubtful that they'd work together in an exhibition.

Printing and framing

The prints you make for an exhibition must be free of technical errors. If a print isn't right in any way it shouldn't be used. Once you've had the prints made you then need to mount and potentially frame them. Mounting prints is relatively inexpensive—particularly if you print your images to a size that matches mounts that can be bought off-the-shelf. If you print to a nonstandard size, you will either have to cut mounts yourself or have the prints mounted professionally.

Framing prints will obviously add considerably to the cost of putting together an exhibition. However, framing your prints will look more professional—you may even find that a gallery owner insists on it. To reduce costs, you could consider using standard sized frames bought from a store. Use frames that are reasonably neutral in design. Bear in mind that you're not buying the frames to suit your own tastes. Simple frames won't date as quickly as more elaborate designs and can be reused for future exhibitions.

If you intend to sell your work, you'll need to think hard about what to charge. Don't undersell yourself, but also don't price yourself out of the market. The price you charge for a print has to at least cover the costs of the materials and any commission you may be charged by the gallery. A reasonable starting point is to charge three times the cost of production of the print plus any commission charges.

FRAMED
Simple frames will have more appeal to potential buyers.

Publicity

Everything is arranged: the venue, the dates, and the prints. Now you need to let people know about the exhibition. This is made easier if you are showing in a gallery since the gallery owner or manager will probably take care of the publicity for you. However, be prepared to talk to the press at the owner's request. Again, this is when having a strong theme for the exhibition will help. A theme will have a better hook for a story than a disparate collection of images. You'll also find it easier to discuss a themed exhibition with journalists, particularly if it's a subject that you feel passionately about.

If you are publicizing the exhibition yourself, send out a well-written press release to local newspapers that clearly states the theme of the exhibition and includes representative images. You should also include relevant contact details as well as the venue and date of the exhibition.

Flyers and posters are a good way to attract attention in the area local to the gallery. Print posters on good inkjet paper so that colors are accurate. If it's possible to fix a poster legitimately outside, then pay to have it laminated so that it will be able to stand up to the elements. Approach local stores and libraries to ask if they'll display posters in a prominent place for you, as well as taking flyers if you have any printed.

Consider having an open evening for your exhibition. Again, if you're in a gallery, the owner may arrange this for you. However, you should be able to invite guests too. Let

them know in plenty of time so they have a chance to arrange their schedules. It's a good idea to invite journalists too. It's another good reason for them to write about you and your exhibition! Although it's wonderful to invite family and friends, they're often not the people who'll buy your prints. Be prepared to invite local business people too. Even if they don't buy prints, it's a good way to make contacts that may be useful in the future. Drinks and party food are a good way to keep people

POSTCARD
This is the front of a postcard that I had printed to publicize my first solo exhibition.

MOODS OF NORTHUMBERLAND
PHOTOGRAPHY BY
DAVID TAYLOR

CLOCKTOWER RESTAURANT
5TH JANUARY – 29TH FEBRUARY 2008

at the exhibition as it adds to the sense of occasion and makes them feel welcome.

Email and social media are powerful ways to alert people to your exhibition. The key is not to alienate people by bombarding them constantly with information. A more subtle and intriguing campaign often works more effectively than aggressive and repetitive marketing. If your exhibition is on over a reasonable period of time, a month say, putting out more publicity halfway through is a good way to remind people that the exhibition is still open.

If you're planning to hold more exhibitions, use the first to gather contact information to build up a mailing list. Put out a comments book inviting people to leave their email address so that they can be told about the next exhibition you hold.

Finally, enjoy yourself. Putting together an exhibition is a steep learning curve but the experience is invaluable.

POSTER *(Opposite)*
Make your exhibition poster eye-catching but readable.

Canon G10, 12mm lens, 1/400 sec. at f/4, ISO 80

SOCIABILITY
Social media web sites, such as Twitter and Facebook, are a great—and free—way to bring your exhibition to public attention.

David Taylor
Landscape Photography

Christmas Exhibition ✳ Free Admission

Hexham Moot Hall 6-11 December 2011 11.00 - 4.00

Prints Calendars Greetings Cards Books

Manufacturer	Paper name	Description
Harman www.harman-inkjet.com	CrystalJet Elite RC Gloss	260g/m² • resin-coated • gloss
	CrystalJet Elite RC Lustre	260g/m² resin-coated • semigloss
Innova www.innovaart.com	FibraPrint White Gloss IFA 09	300g/m² • acid-free • bright-white • gloss
	FibraPrint Warm Tone Gloss IFA 19	300g/m² • acid-free • warm-toned • gloss
	FibraPrint White Semi- Matte IFA 29	300g/m² • acid-free • bright-white • slight sheen finish
	FibraPrint White Matte IFA 39	285g/m² • acid-free • bright white • matte
	FibraPrint Warm Cotton Gloss IFA 45	335g/m² • 100% cotton rag • heavyweight • warm-toned • smooth-gloss
	FibraPrint Ultra Smooth Gloss IFA 49	285g/m² • fibre-based • very smooth-gloss
	FibraPrint Semi-Glazed IFA 58	285g/m² • acid-free • fibre-based • Baryta • semigloss
	Photo Art Smooth Cotton High White IFA 04	215g/m² • 100% cotton rag • smooth matte
	Photo Art Smooth Cotton High White IFA 14	450g/m² • 100% cotton rag • smooth matte
	Photo Art Smooth Cotton High White (Double Sided) IFA 05	225g/m² • 100% cotton rag • smooth matte
	Photo Art Smooth Cotton Natural White IFA 11	315g/m² • 100% cotton rag • smooth • slight sheen
	Fine Art Soft Textured Natural White IFA 06	190g/m² • white • matte • subtle texture

Manufacturer	Paper name	Description
Innova	Fine Art Soft Textured Natural White IFA 12	315g/m² • white • matte • subtle texture
	Fine Art Soft Textured Natural White IFA 22	315g/m² • 100% cotton rag • white • matte • subtle texture
	Fine Art Soft Textured Natural White IFA 07	200g/m² • white • matte • double-sided • subtle texture
	Soft White Cotton IFA 15	280g/m² • 25% cotton rag/75% alpha cellulose • smooth matte
	Canvas Textile Paper IFA 08	315g/m² • acid-free • natural white • canvas-weave texture
	Décor Canvas Matte IFA 32	280g/m² • acid-free • bright white • matte • canvas • textured surface
	Fine Art Canvas Matte IFA 33	340g/m² • acid-free • natural white • matte canvas with a textured surface
	Photo Canvas Matte IFA 35	350g/m² acid-free • bright white • matte canvas with a textured surface
	Photo Canvas Ultra Gloss IFA 36	380g/m² acid-free • bright white • gloss canvas with a smooth woven textured surface
	Art Canvas Textured Matte IFA 37	380g/m² acid-free • bright white • matte canvas with a woven textured surface
	Art Canvas Textured Matte IFA 37	430g/m² • acid-free • bright white • matte canvas with a heavily woven textured surface

Glossary

Aberration An imperfection in the image caused by the optics of a lens.

Acid-free paper Paper that is pH neutral. Acid-free paper is more stable and is therefore considered archival.

Additive color Color produced by light when it falls onto a surface. The three primary colors are red, green, and blue.

Aperture The opening in a camera lens through which light passes to expose the sensor. The relative size of the aperture is denoted by f-stops.

Bind To join sheets of paper together to form a book or other publication either by glue, wire, or other means.

Bracketing Taking a series of identical pictures, changing only the exposure, usually in half or one stop (+/-) differences.

Buffer The in-camera memory of a digital camera.

Center-weighted metering A way of determining the exposure of a photograph placing importance on the light-meter reading at the center of the frame.

Chromic aberration The inability of a lens to bring spectrum colors into focus at one point.

CMYK Shortened form of Cyan, Magenta, Yellow, and Black.

Coated paper Paper that has a coating to improve reflectivity or increase the ability to hold ink. A common substance used for coating is clay.

Color cast Unwanted color tinting either in a digital image or on a print.

Color gamut The range of hues a digital device such as a monitor or printer can reproduce.

Color temperature The color of a light source expressed in degrees Kelvin (K).

Compression The process by which digital files are reduced in size. Compression can retain all the information in the file ("lossless compression"), or lose data ("lossy compression"), usually in the form of fine detail for greater levels of file-size reduction.

Contrast The range between the highlight and shadow areas of an image, or a marked difference in illumination between colors or adjacent areas.

Crop marks Marks added to a print or document to indicate where the paper should be trimmed to after printing.

Deckle edge Ragged edge on paper instead of a clean cut. Often used for art prints.

Depth of field (DOF) The amount of an image that appears acceptably sharp. This is controlled by the aperture: the smaller the aperture, the greater the depth of field.

DPOF Digital Print Order Format.

Diopter Unit expressing the power of a lens.

Dpi (dots per inch) Measure of the resolution of a printer or scanner. The more dots per inch, the higher the resolution.

Dynamic range The ability of the camera's sensor to capture a full range of shadows and highlights.

Evaluative metering A metering system whereby light reflected from several subject areas is calculated based on algorithms.

Exposure The amount of light allowed to hit the sensor, controlled by aperture, shutter speed, and ISO. Also, the act of taking a photograph, as in "making an exposure."

Exposure compensation A control that allows intentional over- or underexposure.

Filter A piece of colored, or coated, glass or plastic placed in front of the lens.

Finish Description of the surface of paper. Paper can be glossy, matte etc.

Focal length The distance, usually in millimeters, from the optical center point of a lens element to its focal point.

f-stop Number assigned to a particular lens aperture. Wide apertures are denoted by small numbers, such as f/2, while small apertures are indicated by large numbers, such as f/22.

Four-color process printing Describes a printing method that simulates a full range of colors by mixing cyan, magenta, yellow, and black ink in varying amounts.

Grammage The weight of paper measured in grams per square meter (GSM).

Histogram A graph used to represent the distribution of tones in an image.

Hotshoe An accessory shoe with electrical contacts that allows synchronization between the camera and a flash (or other compatible device).

Hue A specific color such as red or blue.

Interpolation A way of increasing the file size of a digital image by adding pixels, thereby increasing its resolution.

HDMI High Definition Multimedia Interface.

ISBN Shortened form of International Standard Book Number. An ISBN is a unique number used to identify a commercially published book.

ISO (International Organization for Standardization) The sensitivity of the sensor measured in terms equivalent to the ISO rating of a film.

JPEG (Joint Photographic Experts Group) JPEG compression can reduce file sizes to about 5% of their original size.

Laminate A coating—usually plastic—applied to a print to protect the surface.

Landscape Orientation of an image where the width is greater than the height. Less confusingly referred to as horizontal.

LCD (Liquid crystal display) The flat screen on a digital camera that allows the user to compose and review digital images.

Macro A term used to describe close-focusing and the close-focusing ability of a lens.

Megapixel One million pixels equals one megapixel.

Memory card A removable storage device for digital cameras.

Metallic paper Paper with a plastic coating that appears metallic.

Neutral gray Gray that has no color tinting.

Noise Colored image interference caused by stray electrical signals.

PictBridge The industry standard for sending information directly from a camera to a printer, without having to connect to a computer.

Pixel Short for "picture element"—the smallest pieces of information in a digital image.

Portrait Orientation of an image where the height is greater than the width. Less confusingly referred to as vertical.

Proof Print made to test the accuracy of colors etc. before a final print is made.

RAW The file format in which the raw data from the sensor is stored without permanent alteration being made.

Resolution The number of pixels used to capture or display an image.

RGB (red, green, blue) Computers and other digital devices understand color information as combinations of red, green, and blue.

Rule of thirds A rule of thumb that places the key elements of a picture at points along imagined lines that divide the frame into thirds.

Shutter The mechanism that controls the amount of light reaching the sensor, by opening and closing.

Subtractive color Color produced by light reflecting from a surface.

Telephoto A lens with a large focal length and a narrow angle of view.

TTL (through-the-lens) metering A metering system built into the camera that measures light passing through the lens at the time of shooting.

TIFF (Tagged Image File Format) A universal file format supported by virtually all relevant software applications. TIFFs are uncompressed digital files.

USB (universal serial bus) A data transfer standard, used by most cameras when connecting to a computer.

Viewfinder An optical system used for composing, and sometimes for focusing the subject.

Vignette Specific term in printing to fade an image to white around the edges.

White balance A function that allows the correct color balance to be recorded for any given lighting situation.

Wide-angle lens A lens with a short focal length and consequently a wide angle of view.

Useful web sites

Hardware

Brother
www.brother.com

Canon
www.canon.com

Epson
www.epson.com

HP
www.hp.com

Kodak
www.kodak.com

Lexmark
www.lexmark.com

Supplies

Ilford
www.ilford.com

Lyson
www.lyson.com

Marrut
www.marrutt.com

Paper Manufacturers

Canson
www.canson-infinity.com

Fotospeed
www.fotospeed.com

Fujifilm
www.fujifilm.com

Hahnemühle
www.hahnemuehle.com

Harman
www.harman-inkjet.com

Hawk Mountain
www.hawkmtnartpapers.com

Ilford
www.ilford.com

Innova
www.innovaart.com

Moab
www.moabpaper.com

Museo Fine Art
www.museofineart.com

PermaJet
www.permajet.com

St Cuthberts Mill
www.stcuthbertsmill.com

General

David Taylor
Landscape and travel photography
www.davidtaylorphotography.co.uk

Digital Photography Review
Camera and lens review site
www.dpreview.com

Photography Publications

Photography books & Expanded Camera Guides
www.ammonitepress.com

Black and White Photography magazine
Outdoor Photography magazine
www.thegmcgroup.com

Index